W9-CNI-707

NEW ART
I N T E R N A T I O N A L

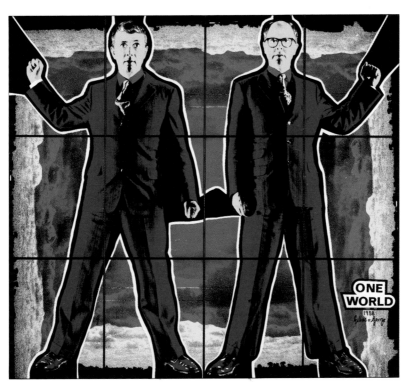

Gilbert & George, *One World*, 1988, photographic montage, 226x254cm, from the recent exhibition held in the Central House of the Artists at the New Tretyakov Gallery Building, Moscow, 1990. In the accompanying catalogue, which combines Russian and English texts, the artists' statement reads: 'We are delighted to realise our old ambition to show our Art to the people of the USSR. We want each Picture in this exhibition to extend a human hand of friendship and culture across the historical and political East/West divide.'

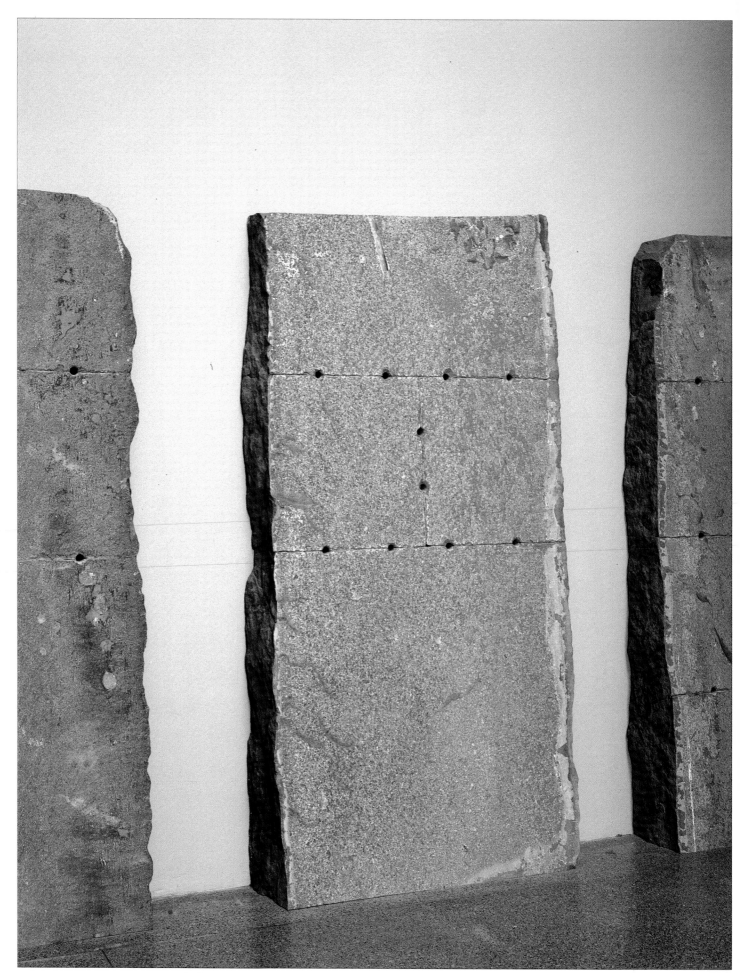

Ulrich Rückriem, *Untitled* (detail), 1989, dolomite stone, four parts, each 1800x1100x35cm

An Art & Design Profile

NEW ART
INTERNATIONAL

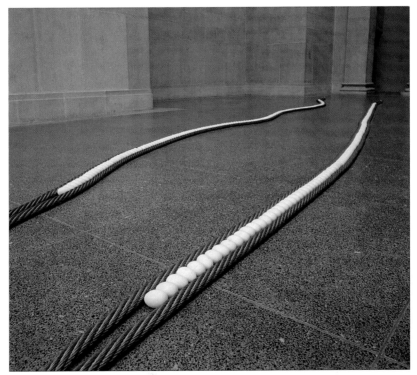

Luciano Fabro, *Ovaie*, 1988, marble and rope, 5x15x1000cm. Installed in the New European
Sculpture Room as part of the recent rehanging at the Tate, both the Fabro and the Rückriem
(opposite), were purchased by the Patrons of New Art.

ACADEMY EDITIONS • LONDON / ST. MARTIN'S PRESS • NEW YORK

In the light of much current thinking and critical discussion on new art and its position in the context of art history – an issue highlighted by Jan Hoet's manifesto for the 1992 Documenta, and Nicholas Serota's highly praised rehanging at the Tate, *Past, Present and Future* – this issue takes its impetus from a number of recent international exhibitions which have aimed at perceiving and defining patterns in contemporary art, including *A Forest of Signs* at MOCA in Los Angeles, *Strange Attractors: Signs of Chaos* at The New Museum of Contemporary Art, New York, and *Image World: Art and Media Culture* at the Whitney Museum in New York.

Acknowledgements: *Front Cover*: SteinGladstone NY; *Back Cover*: Lisson Gallery; *Inside Front Cover*: *Image World*, Whitney NY; *Inside Back Cover*: *Image World*, Whitney; *Half-Title*: Gilbert & George and Anthony d'Offay, text from *Moscow* exh cat 1990; *Title*: Tate; *Frontis*: Tate; *Contents*: Waddingtons. **In Search of the New** *pp6-13*: *pp6-7* Sonnabend Gallery NY; *p8* Barbara Gladstone Gallery NY; *p10* from *A Forest of Signs*, Jay Gorney Modern Art NY and Isabella Kacprzak, Cologne; *p11* Mary Boone; *p12* Metro Pictures NY. Interview by Clare Farrow. **European Sensibility Today** *pp14-19*: This essay was originally published in Italian in the exhib cat *Europa Oggi*, 1988, Museo d'Arte Contemporanea, Prato, published by Centro Di della Edifimi, Florence, and Electa, Milan; *p14* Galerie Daniel Templon; *p15* Lisson Gallery, photo Gareth Winters; *p16* Museo d'Arte Contemporanea, Prato; *p17* Castello di Rivoli installation, Museo d'Arte Contemporanea, Turin 1988-89, artist's collection; *p18* Saatchi Collection; *p19* Galleria Giorgio Persano, Turin. **A Critique of Jean Baudrillard** *pp20-23*: This text is an extract from 'The Postmodern Carnival', Ch4 of *Jean Baudrillard, Marxism to Postmodernism and Beyond*, Polity Press, in assoc with Basil Blackwell, 1989, Oxford, published here by permission of the author and publishers; *p23* Sonnabend. **Christian Boltanski** *pp24-29*: Lynn Gumpert is an independent curator living in New York. While Senior Curator for The New Museum of Contemporary Art, New York, she co-organised *Christian Boltanski: Lessons of Darkness*. Recently, she contributed an essay to the *Christian Boltanski* exh at the Whitechapel, London which is travelling to the Van Abbe Museum, Eindhoven and the Musée des Beaux Arts, Grenoble; *p24, 25, 26, 28* Galerie Ghislaine Hussenot, Paris; *p27* photo Ralph Hinterkeuser, Galerie Julie Keweenig, Frechen-Bachem. **Unexpressionism** *pp30-39*: This text comprises extracts from *Unexpressionism – Art Beyond the Contemporary*, 1988, Rizzoli, NY; *p30* Salama-Caro, London; *p31* and *p34* Metro Pictures; *p32* Barbara Gladstone; *p33* and *p35* Max Hetzler, Cologne; *p36* Mary Boone; *p37* Galeria Tucci Russo, Turin, photo Enzo Ricci; *p38* Josh Baer Gallery NY; *p39* Sonnabend; *pp40-41* John Weber Gallery NY, Serpentine Gallery, artist's statements: DA Robbins, 'An Interview with Allan McCollum', *Arts Magazine*, Oct 1985; Selma Klein Essink, interview 1989 and artist's statement 1981, 'Allan McCollum; The Function, Meaning and Value of an Artwork', Serpentine cat 1990. **Into the Words: Thoughts on A Forest of Signs** *pp42-47*: ills from the exh, *p42* Barbara Gladstone; *p43* from exh cat, the artist and Mary Boone; *p44-45* MOCA, LA, photos Gene Ogami; *p46* MOCA, LA, *Above* photo Squidds and Nunns; *p47* 303 Gallery NY. **The Power of Seduction** *pp48-53*: *pp50-51* Sonnabend; interview by Clare Farrow. **The Strange Attraction of Chaos** *pp54-61*: An earlier version of this essay by curator Laura Trippi, 'Fractured Fairytales, Chaotic Regimes', appeared in the *Strange Attractors: Signs of Chaos* cat, The New Museum of Contemporary Art NY, Sept 13-Nov 26, 1989; ills from The New Museum of Contemporary Art. **Victor Burgin – Minnesota Abstract** *pp62-65*: The author is Professor of Art History and History of Consciousness at the Univ California, Santa Cruz; his books include *Between* and *The End of Art Theory: Criticism and Postmodernity*; *p62* and *65* Liliane & Michel Durrand-Dessert, Paris; *p63* the artist. **Jenny Holzer: Lamentations** *pp66-69*: Barbara Gladstone and DIA Art Foundation; reproductions of original drawings for inscriptions on 13 stone sarcophagi installed at the DIA Art Foundation NY, 1 March 1989-18 Feb 1990, published in exh cat, are published here courtesy DIA Foundation. **David Salle** *pp70-71*: Waddington Galleries; interview by Clare Farrow. **Going Public** *pp72-77*: The author is an artist and critic living and working in New York; *p72* Fisher Park and Elephant House productions, photo Chris Rodley, ICA; *p73* the artist; *p74* DIA Art Foundation; *p75* the artist; *p76* Mary Boone; *p 77* Whitney NY. **Tim Rollins + KOS** *pp78-81*: Interim Art, London. **Image World – Art and Media Culture** *pp56-61*: Lisa Phillips is curator of the Whitney Museum NY and, together with Marvin Heiferman and John Hanhardt, curated the Whitney's *Image World* exh, Nov 1989-Feb 1990. This text is extracted from her catalogue essay, 'Art and Media Culture'; ills by kind permission of the Whitney. **The Art of Alchemy** *pp86-93*: *p86* originally installed at *The Palace of Good Luck* exh, Museo d'Arte Contemporanea, Castello di Rivoli, 1989; *p87* Henry Moore Sculpture Trust, Dean Clough, Halifax; *p88* Galerie des Beaux-Arts, Brussels; *p90* Anthony d'Offay; *p91* Gagosian Gallery NY; *p92* Marlborough Gallery. **The Temporality of the New** *pp94-96*: *p94* *Image World*, Whitney.

EDITOR
Dr Andreas C Papadakis

EDITORIAL OFFICES: 42 LEINSTER GARDENS LONDON W2 3AN TELEPHONE: 01-402 2141
HOUSE EDITOR: Clare Farrow ASSISTANT EDITOR: Nicola Hodges DESIGNED BY: Andrea Bettella, Mario Bettella
ADVERTISING: Sheila de Vallée SUBSCRIPTIONS MANAGER: Mira Joka

First published in Great Britain in 1990 by *Art & Design*
an imprint of the
ACADEMY GROUP LTD, 7 HOLLAND STREET, LONDON W8 4NA
ISBN: 1-85490-018-8 (UK)

Copyright © 1990 the Academy Group. *All rights reserved*
The entire contents of this publication are copyright and cannot be reproduced
in any manner whatsoever without written permission from the publishers

The Publishers and Editor do not hold themselves responsible for the options expressed by the
writers of articles or letters in this magazine
Copyright of articles and illustrations may belong to individual writers or artists

Art & Design Profile 19 is published as part of *Art & Design* Vol 6 1/2 90
Published in the United States of America by
ST MARTIN'S PRESS, 175 FIFTH AVENUE, NEW YORK 10010
ISBN: 0-312-03983-2 (USA)

Printed and bound in Singapore

David Salle, *Doors with Light*, 1989, acrylic and oil, 274.3x365.7cm (see interview with the artist, p70)

Contents

Robert Rosenblum In Search of the New 6
Donald Kuspit European Sensibility Today 14
Douglas Kellner A Critique of Jean Baudrillard 20
Lynn Gumpert Christian Boltanski – An Interview 24
Germano Celant Unexpressionism 30
Brooks Adams Thoughts on *A Forest of Signs* 42
Jeff Koons The Power of Seduction 48
Laura Trippi The Strange Attraction of Chaos 54
Victor Burgin A Note on Minnesota Abstract 62
Jenny Holzer Lamentations 66
David Salle An *Art & Design* Interview 70
Thomas Lawson Going Public 72
Andrew Renton Tim Rollins + KOS 78
Lisa Phillips Image World – Art and Media Culture 82
Antje von Graevenitz The Art of Alchemy 86
Andrew Benjamin The Temporality of the New 94

© 1990 *Academy Group Ltd*. All rights reserved. No part of this publication may be reproduced or transmitted in any form or by any means, electronic or mechanical, including photocopying, recording or any information storage or retrieval system without permission in writing from the Publisher. Neither the Editor nor the Academy Group hold themselves responsible for the opinions expressed by writers of articles or letters in this magazine. The Editor will give careful consideration to unsolicited articles, photographs and drawings; please enclose a stamped addressed envelope for their return (if required). Payment for material appearing in *A & D* is not normally made except by prior arrangement. All reasonable care will be taken of material in the possession of *A & D* and agents and printers, but we regret that we cannot be held responsible for any loss or damage. *Subscription rates for 1990 (including p&p):* Annual Rate: UK only £39.50, Europe £45.00, Overseas US$75.00 or UK sterling equiv. Student rates: UK only £35.00, Europe £39.50, Overseas US$65.00 or UK sterling equiv. Combined subscription with *AD*: UK only £75.00, Europe £85.00, Overseas US$135.00 or UK sterling equiv. Special student combined subscription: UK only $65.00, Europe £79.50, Overseas US$120.00 or UK sterling equiv. Individual double issues £7.95/US$14.95. Plus £1.00/US$3.00 per issue ordered for p&p. Printed in Singapore. [ISSN: 0267-3991]

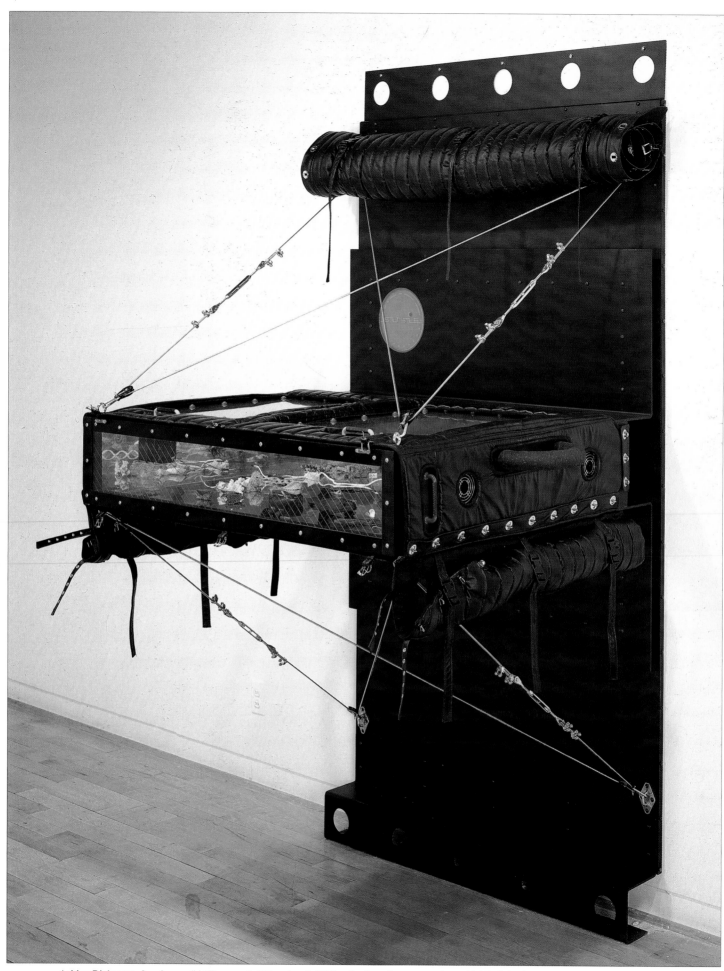

Ashley Bickerton, *Landscape #4 (Fragmented Biosphere)*, 1988, mixed media construction with black leather cover, 244.5x152.4x111.8cm

ROBERT ROSENBLUM
IN SEARCH OF THE NEW
An Art & Design *Interview*

Haim Steinbach, *Untitled (Somalian Container, American Baskets)*, 1989, mixed media construction, 92.7x198.1x50.8cm

Acknowledging the significance of art history in the context of new art in the 80s and 90s, Rosenblum here discusses the definitions, trends and phenomena currently circulating the international art world. Commenting on a number of recent exhibitions, he consolidates his thoughts on issues such as originality, invention, continuity and the relevance of conventional terminology in defining the new.

By selecting new art as the focal point of this discussion, one must inevitably begin by questioning the concept of the new in the context of contemporary art. New York is considered by many to be the centre for new art. But beyond the market's constant demand for novelty and the emergence of unknown artists onto the international scene, is it possible to define an art that is actually exploring new ground?

I don't know how one can make a clear distinction between new art, meaning something unseen before and fresh, and art that is exploring grander, more serious new territory. That will have to be something that settles into history. What I find phenomenal is the way in which new art seems to have a shorter and shorter lifespan; the very concept of the new seems to be so ephemeral that it's quite useless. For instance, in 1988 Jeff Koons might have seemed like the newest of new artists and suddenly in 1989 he seemed like an old master. Now in the 90s we are no longer thinking about him as a new artist and he has left a void for another new artist to fill. So the concept of newness has been so diminished in terms of timespan that Andy Warhol's prophecy about everybody being famous for 15 minutes seems to have been reduced to 15 seconds!

Part of the concept of the new also has to deal with the concept of what is new in the old, since reputations among mid-20th-century artists from the 40s, 50s and 60s are now being resur-

rected and turned into something that is hot and new. An interesting phenomenon concerns the whole generation of 1960s Colour-Field painters written about by Greenberg and his disciples. The younger and newer elements of the 70s and 80s completely ignored them, but now they are being re-exhibited and re-experienced, often producing the same effect of novelty and shock as the younger generation. Similarly, countless artists from the 19th century are being excavated, dusted off and given new reputations, so it's not really a phenomenon that is confined to contemporary art. In that sense, the search for novelty, for freshness, for something that is unfamiliar, all helps to keep the art market going. I don't mean this as a negative thing, I'm just describing a phenomenon that is very familiar today.

You don't agree with critics who might see this as a sign that art has been exhausted, that everything has been invented, and that all that remains is to re-experience and restructure the language of art history?

Things have not really changed, artists have always quoted from the past. Manet spent the early part of his career creating great paintings that were quotations from the past and Sir Joshua Reynolds did appropriations all the time. But this did not mean that the history of art was exhausted, it just meant that they re-invented tradition in their own unexpected ways. So I don't think for an instant that that is the situation today.

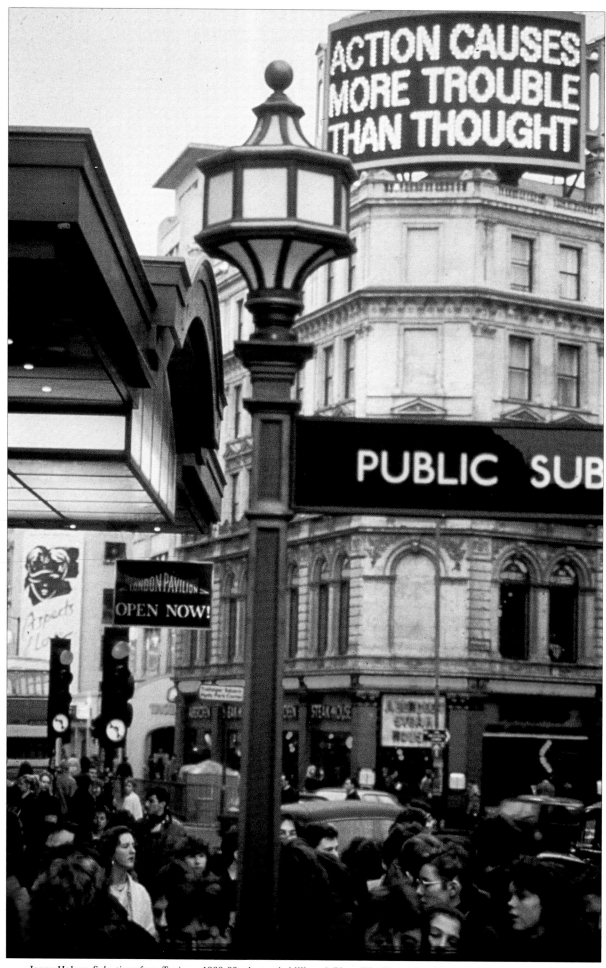

Jenny Holzer, *Selections from Truisms*, 1988-89, electronic billboard, Piccadilly Circus, London, sponsored by Artangel Trust

– Germano Celant, in his text on 'Unexpressionism', has written that 'What we perceive is not the "new" but the linguistic reflection on the persuasive and communicative ability of things that are already made. Previous knowledge is rearranged, and no "newness" is sought.' Would you agree with this statement?
I don't know if that is true, since it always turns out that the art of the past – and it is as true for Cubism or Abstract Expressionism as it is for art today – when it was first seen appeared to be startlingly new but was subsequently rearranged both linguistically and historically as a perfectly logical continuation of existing art forms.

– Jeff Koons has recently described the creative process in terms of rearranging existing chemical compounds to form something totally new.
I like that idea and I think about it in particular in terms of his own work. When I first saw the beautiful kitsch sculptures that he exhibited last year I was absolutely bowled over and shocked with both pleasure and horror. I found them really startling and they made me feel as though the ground had shaken. Then I discovered that this 'shock of the new' (to use a traditional phrase) was something that I had experienced when I first saw the comic-strip paintings by Roy Lichtenstein over a quarter of a century ago. His paintings had the same combination of something that began as ugly but that turned out to have a new kind of beauty. So Jeff Koons initially seemed to be very, very new but he subsequently came to seem like a modern mutation of an experience that I had already had. Then in turn, looking at Lichtenstein I remember having the feeling that, although this seemed totally unprecedented, it was to be construed, at least by me, as a recombination of components that one can find, say, in the work of Seurat, who was so excited by cartoons, caricatures and commercial illustrations, and perhaps even in some aspects of Cubism. However new something seems at first, you quickly get used to it and then in retrospect it seems to be part of a long Darwinian evolution. So I don't really think that Koons' work is earth-shaking, it is just an unfamiliar combination that seems totally new, but when investigated begins to reveal its traditional roots.

– What art have you seen recently that has struck you as being new and unfamiliar?
Two days ago I saw the Ashley Bickerton show and, although I'm familiar with his work, his latest show at first seemed startlingly unfamiliar. I was really rivetted by his images and constructions which looked like something from a different planet. Once again I'm sure we will get used to them and begin to see all sorts of precedents, but at least for the time being they threw me. Even Jenny Holzer's use of electronic sign boards, which in itself was startlingly new a few years ago, has become very familiar. Exactly the same thing has happened to Dan Flavin. When we first saw one of his fluorescent light tubes his art seemed totally unprecedented. Then, as the medium became familiar, we became fascinated instead by his combinations of light tubes. The same thing has now happened with Jenny Holzer. Initially the medium itself seemed startlingly new but now the electronic signs just look like 'Jenny Holzers' and we are interested, not in the novelty of the medium, but in the various new combinations and permutations of her style. It's just a principle that there is nothing new under the sun; rather there are new variations of existing things. Whatever the discipline, you can't make something totally new out of nothing; it will always have its roots.

– Analysing the constant changes and novelties in his work over the last decade, Jeff Koons seems to communicate a sense of the accelerated history of the commercial art world and the emphasis on the new. Do you see this as a very self-conscious aspect of New York art at the moment?

Yes, I think this is certainly the case with Jeff Koons, and other artists like him. Part of the force of his art has to do with his irony. He is completely aware of the art-as-commodity situation today and, instead of throwing up his hands and bemoaning the fact that art used to be alienated and spiritual, he is embracing the current facts of life. The feeling is that if you can't beat it, join it. He is making the most of his art, treating it as fashion and changing the season's model. I don't see why he shouldn't, it is his approach to it and it's a perfect reflection of the business world of art today.

– Can you account for the current resurgence of interest, on the international scene, in Conceptual artists such as John Baldessari, Bruce Nauman and Joseph Kosuth? How does the new Conceptualism compare to that of the 70s and is it a sign that the 80s tendency towards Expressionism has been exhausted?
I would never say that anything has been exhausted. It seems to me that Nauman, Baldessari and Kosuth were kind of leapfrogging in terms of their art. They represented for a long time the kind of 'hands off' art of the 70s – 'hands off' in the sense that they never looked as though they were using traditional means of making paintings or constructions. They looked pretty irrelevant for a while, but now that so many artists are trying once again to reflect the whole world of commerce, of signs, images, television, billboards, electronic sign boards etc, these artists certainly have a new 'ancestor' look and I think that's probably the reason for their sudden relevance. However, the new artists have a much more hip, younger-generation attitude towards commerce and luxury goods than the 70s artists ever did. I'm thinking in particular of Barbara Bloom. Her grain of narcissism is something that comes ultimately from that 70s mould but it has a completely new flavour which has to do with high luxury and total vanity, total narcissism, which is a perfect mirror of artists in society today. She is, in terms of influence, taking us back to the art of the 70s and has skipped over figurative painting, but I certainly don't think that's dead. We all know from the history of art that every time something is deemed to be dead it resurfaces a few seasons later, so I never believe in any such statements.

– Many artists seem to be distancing themselves more and more from the artworks themselves, adopting a certain objectivity towards their art, and embracing other roles such as that of the critic, the philosopher, the spokesman and writer, placing an increasing emphasis on the use of photography and language.
That is true insofar as there certainly seems to be a whole new wave of young artists getting as far away as they can from the hand-made and that look of the hand-made which was a kind of signature of anti-Conceptual art in the early 80s. So I think that this is probably the kind of generalisation that holds, but that is not to say that there is not a lot of good hand-made painting and sculpture going on now and that it cannot just as quickly replace the synthetic, commercial look of so much good art of the late 80s. I think actually they are running concurrently. I don't think of it as first black, then white; I think these tendencies are going along together now.

– Can we discuss the influence of the media on new art, an issue that has been highlighted in a number of recent exhibitions including A Forest of Signs *in Los Angeles and* Image World: Art and Media Culture *in New York?*
All we have to do is to look at the attitude of Haim Steinbach, Barbara Kruger, Jenny Holzer or Ashley Bickerton to realise that the whole look of the modern world is being mirrored back to us by them and this seems very, very fresh. However, yet again, the newness of it is only relative because that immediately reminds me of the way in which James Rosenquist, in the 1960s, was using images from advertising billboards, and Lichtenstein and Warhol suddenly forced us to re-think images from daily newspapers. So it's an old story in the history of art; this is just the

Barbara Bloom, *The Reign of Narcissism*, (detail), 1988-89, mixed media installation, hexagonal room, 609.6x609.6x365.8cm

latest chapter in it.

– *Baudrillard has described the influence of consumer signs and mass-media images in terms of 'this new hyperreality', a phenomenon that Donald Kuspit sees as distinguishing and defining the American culture. Can you comment on this?*

Well I think certainly the experience of facsimiles, of being bombarded by replicas of everything, the sheer abundance of commercial signs – this has always been more obvious in America than in Europe and the whole history of 20th-century American art is proof of the fact. On the other hand, I think that it's much too easy to turn this into a black and white situation as French thinkers such as Baudrillard always do.

– *Do you think that new art can be politically effective?*

No, I have never thought that any art, certainly any art of the last ten or 20 years that has had a political position has been in any way politically effective. Basically the audience is much too narrow. You can't have politically effective art because only the art world sees it. Even if, within that world, it is at first shocking or makes people twinge with embarrassment at their values or lack of them, you soon get immune to that. That's one of the things about Jenny Holzer. Although you may read her messages, and some of them really hit hard, you swiftly forget about the messages and just look at them as a kind of light spectacle.

That's certainly what happened in the last show at the DIA Foundation. I think that is true about Hans Haacke or Leon Golub, both ferociously political artists. They make us face, make us confront head on, some of the hardest human and economic issues of our times. But the fact of the matter is that they very quickly look just like a good or a bad 'Hans Haacke', or an early or a late 'Leon Golub'. So I really think that although political ambitions may fire artists and make them work, in the end they have no effect.

– *Do you think this is because the artists you mention are operating from within the commercial market and have become successful and acceptable within that context?*

Well that's certainly part of it. The fact of the matter is that the collectors will instantly buy, and the dealers will immediately show whatever's supposed to be offensive or counter-establishment, and the swiftness with which such art is now accepted as art is absolutely dumbfounding. I rather think that if Picasso's *Guernica* was exhibited for the first time today, it would immediately be thought of only as a work of art and not as a political painting. But what's happening in fact has always happened, for even *Guernica*, which had such a strong message, very quickly became just another painting by Picasso of 1937. I don't believe that art can save lives or change people's politics

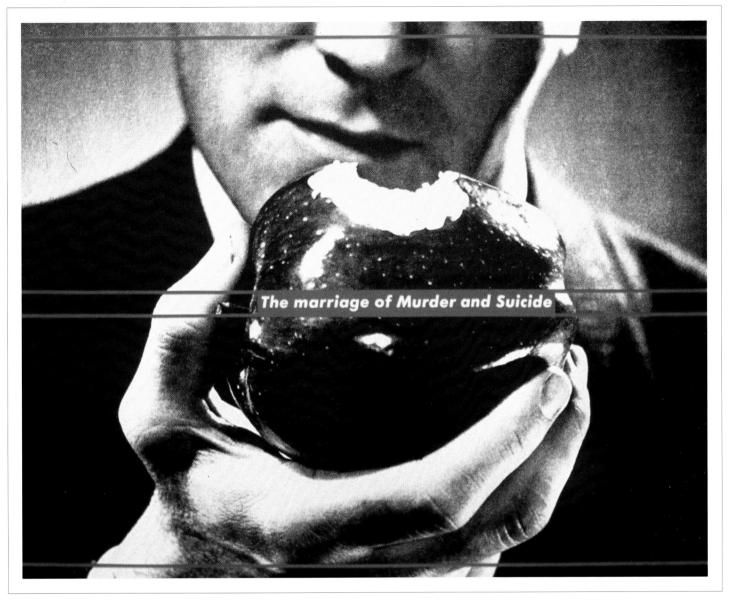

The marriage of Murder and Suicide

Barbara Kruger, *Untitled* (*The Marriage of Murder and Suicide*), 1988, photographic sillkscreen/vinyl, 205.7x259.1cm

and attitudes. But I don't deny artists the right to feel that they can change the world.
– *So you do not believe that artists can really communicate to a mass audience?*
I think that statistically artists have communicated to a mass audience. And certainly if by communication you mean that more and more people know their names and look at their work, there can be no doubt that the audience today is much larger than it has ever been in the history of art, but I don't know whether this communication is effective.
– *Do you see the many interviews, writings and statements by artists as an effective means of communicating their ideas to a larger audience?*
Well, to be honest, I think it's not so much part of communicating, it's just part of the whole commercial network. The interviews with artists, not to put down the seriousness of what the artists say, are really another form of advertising. The truth of the matter is that very few people read them, in fact few people read most of the art texts which are being published in large quantities today. So I think that statements are just another form of publicity and of course interviews are just like taking out a couple of two or three page ads which you see again and again and that's part of their message. It's certainly part of mine here.

– *Do you think there is a problem in reconciling the many critical and theoretical interpretations surrounding new art with the writings and statements of the artists themselves?*
I think this has always been the case; for instance at the time of the Abstract Expressionists there were endless speculations about the parallels with Existentialism. That is just one example. The whole history of the response to Cubism in the early 20th century has been riddled with quasi-philosophical explanations, not to mention Einsteinian physics and so on, and this has generally tended to blow a lot of foggy air around the art. So there are things said about all kinds of art that the artists themselves may not even understand, but the situation itself is not new and it usually evaporates, leaving the art behind.
– *In the catalogue text to* A Forest of Signs *the curators stated their aim as being to show 'history in the making', 'history not yet fully written'. Do you think there is a growing tendency among contemporary art museums to play a more active role in defining and promoting new art?*
Yes I think so and I am very grateful for the experience of having seen *A Forest of Signs*. I am New York based and the story here is that it is usually assumed that because we have all the galleries we don't need the museums to make anthologies for us and to tell us what is going on. But if you have a wise curator, as in the case

Cindy Sherman, *Untitled*, 1989, colour photograph, 104.1x81.3cm

of *A Forest of Signs*, then she can pull things together and make order out of the confusion of the contemporary and perceive patterns of similar artists while the patterns are being established.

– How important are alternative artists' spaces in promoting new art?

My own guess is that they are not very important. Whether we like it or not, the huge glut of art today really means that you only have time to pay attention to what you hear most about, and what you hear most about is effectively what is being publicised. I think the idea of alternative spaces is an idealistic situation but in reality it is one that doesn't work. You have to make your choice from just a handful of galleries and they tend to be the famous and international galleries.

– Victor Burgin has said that 'the job for the artist is to dismantle existing communication codes and to recombine some of their elements into structures which can be used to generate new pictures of the world'. Do you think that the use of photography by contemporary artists is succeeding in generating 'new pictures of the world'?

Yes. I think it's a story that begins with Rauschenberg and Warhol in the late 50s and early 60s. They were really the first artists to use photography in high art, in paintings and constructions, and these artists are new variations on that theme. The problem was how to re-introduce images from the real world into the ivory tower of painting. People like Rauschenberg and Warhol realised that the contemporary way to do it was to use the kinds of images that were being used in the media and were being reflected in photographs, so that their mixture of photography and non-photography is really critical in artists like Victor Burgin, Thomas Lawson and Richard Prince. They're really modern variations on Warhol's use of photography. What I do find very bewildering is how to distinguish between photography as photography and as non-photography or as painting. It's a very strange distinction and one that is becoming less and less clear, but this hybrid form is one that has become more common to our experience. It's typical that the work of Cindy Sherman is not in the domain of modern painting and is equally not in the domain of photography. It is in the domain of, I hesitate to say it, high art – it's such a broad term. It's very funny that we're uncertain in distinguishing between the two territories. I remember at the *History of Photography* exhibition at the Royal Academy in London, it was to my pleasure and surprise that Andy Warhol and Christian Boltanski were included and I suddenly realised that, although I had never thought about them as being in the history of photography, they were really quite relevant to the history of this kind of art. So the confusion or fusion is now at a maximum.

– Would you categorise the work of the Starn Twins, who fragment and transform the photographic medium, in terms of art rather than photography?

It is true that the audience for the Starn Twins seems to be more and more an art audience rather than a photography audience. In fact they have recently been doing things with photographs of paintings by Picasso so that they are now trespassing on the territory of artists who did art about art. In the same category, Gilbert & George always seem to have that art constituency but in fact they could just as easily be fixed in the history of photography. The boundaries are very ambiguous.

– David Salle has recently exhibited his new paintings at Waddington Galleries in London. Do you think his art has changed in any way, and where would you place him in the context of new art?

My impression from his last show in New York is that he hasn't changed in any significant way; although perhaps he has changed in terms of his theatre sets of which I have only seen photo-

graphs. But my sense of him now is that he's a kind of old master. That sounds strange with such a short career, but he has had a big show at the Whitney already and he is a perfect example of how the new is no longer new. There is no question that he belongs to an older generation of establishment figures.

– Would you put Julian Schnabel into the same category?

Exactly. One looks back to them as one looks back to history. It's a funny phenomenon although they have been around for quite a while, practically a decade. I sometimes think we consider the tempo of art is so rapid now but one realises, as we just did here in New York with the Cubist Show at the MoMA, that what we're looking at is only seven years of work by Picasso and Braque between 1907 and 1914. By the end of seven years the whole thing looked museum-worthy and everything looked quite different directly afterwards. The tempo of change has always been more rapid than you would think. When you experience it of course it seems much faster, but in retrospect things have always been fast. In terms of their careers, Seurat only lived for a decade and the same is true of Van Gogh, but they changed everything. In the next decade everything was very different. So I don't think the tempo now is quite as rapid as it seems.

– Donald Kuspit has contrasted the sensibilities of American and European artists, arguing that in Europe the orientation tends much more towards memory, and that the emphasis is not on the new, it's not on the future, but is much more concerned with coming to terms with the past. Would you agree?

It's certainly true of many German artists, and I know that Donald Kuspit has been particularly prolific in writing on the contemporary German situation. The history of retrospection, both political and aesthetic, is certainly much stronger in Germany than it is here. On the other hand I also think that the look of many new artists here, from Barbara Kruger and Haim Steinbach to Jeff Koons is also, to a certain extent, a question of looking back because much of this can be thought of as a kind of recycling of the 60s and the whole American tradition of embracing the modern. Every situation has its retrospective character and this does as well. But clearly the situation in Germany is concerned with memory and that's probably true in Italy as well.

– In Germany, the influence of Beuys on younger artists seems to be as great as that of Warhol in America.

I think it's amazing, although it may just be a false polarity, but both Warhol and Beuys have been set up as major father-figures. Every young artist in America looks back with some veneration to Warhol, and in Germany the same can be said for Beuys.

– Do you think it is important for artists to confront international issues? Would you describe Jeff Koons' work for example as being international?

I think it's international in the sense that the audience for that artist's work is global but that doesn't mean that the character of his work is *esperanto*. I think it's just a phenomenon of the airport vision of art exhibitions that take place all over the world. I think good artists tend to be international in that their work is seen all over the world. But I think that the concept of being an international artist in terms of having no national inflection is unfounded. I can't think of an artist who can be seen in those terms. It is possible that art will eventually become international due to the fact that people can travel so much and that art travels so much and the very clear distinctions between traditions have blurred. Nevertheless it strikes me that Jeff Koons, like Barbara Kruger or Jenny Holzer, is very American. I can't imagine their work being made by anybody outside New York, nor can I imagine Gilbert & George being anywhere other than London; likewise Kiefer couldn't be anything but German. I don't see artists as being internationalised except in terms of commerce.

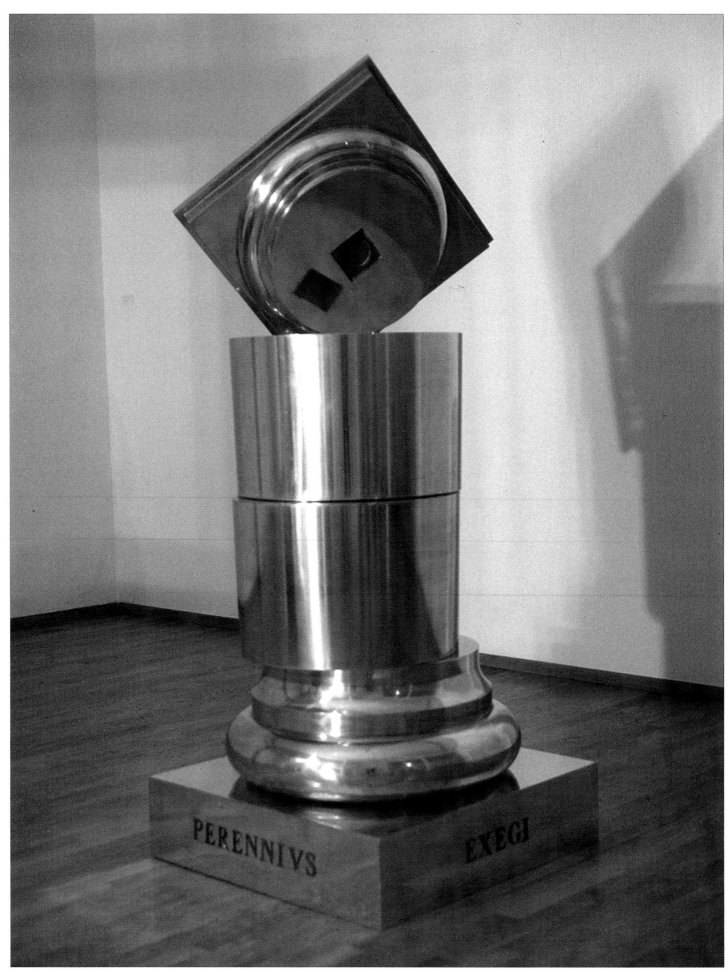

Anne and Patrick Poirier, *Exegi Monumentum Aere Perennius*, 1988, cast aluminium, 193x80x80cm

DONALD KUSPIT
EUROPEAN SENSIBILITY TODAY

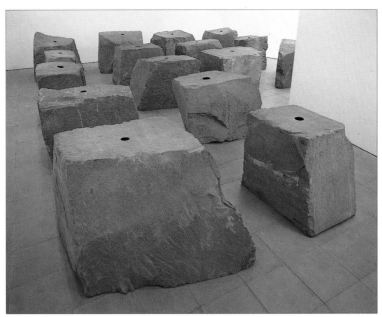

Anish Kapoor, *Void Field*, 1989, sandstone and pigment, dimensions variable

Is it possible to find a common ground of sensibility for contemporary European art? Isn't it foolhardy to attempt to find unity in what is so obviously disparate? Doesn't it blur important differences between the artists, and isn't it epistemologically naive, even absurd, to suppose that there must be an underlying 'cause' or 'mood' they have in common? Hasn't the very notion of a

hidden universality become suspect – become an empty transcendence, an ignorant assumption of substratum less innocent than it looks, for it does enormous damage to particular existences and fosters incredible misunderstandings of them? Discontinuity, not continuity, is the rule understanding today; the assumption of uncontradictory relationships is the big intellectual lie. A century's epistemological warnings against weaving different existential threads in one intellectual rope should make us wary of any construction of sensibility. Yet lurking within all the differences, stylistic as well as materialistic, generational as well as national, it seems to me there is a situation-bound emotional approach that makes for a certain unconscious communality among European artists, that makes the conscious individuality of each seem less absolute. There is a certain common intuition, hardly whispered, among contemporary European artists, whatever their separate histories.

Today, the way to an understanding of Europe is through America (and vice versa), and the way to an understanding of European sensibility is no different. Each is implicitly the background for the other, through socio-historical circumstance, including not only their mutuality within that peculiarly metamorphic transcendent substance called 'Western Civilisation', but more particularly because they are major partners in 'information exchange', each always looking over its shoulder at the

other in what has become the quintessential activity of the Information Age. There is no way of being contemporary or current – carried along by the current – without being aware of what is happening elsewhere, especially in some other place that is implicitly assumed to be as important as one's own, if not secretly envied for being more important (or expected to be). Europeans have envied post-war American art, beginning with Pollock's trend-setting all-over paintings of the late 40s, and continuing through the 60s, with its fast-paced, highly innovative production (ranging from Pop art and Minimalism through Earth art and Conceptual art), and finally into the 70s, when a highly diversified, so-called pluralistic art scene (largely but not exclusively orientated to such social issues as feminism and the Vietnam War) was created. But at the beginning of the 1980s, with the *New Spirit in Painting* exhibition in London, and various other European, mostly German international, exhibitions, which retrospectively seem to have come hard on the heels of each other, Americans have envied (even hated) Europeans for their art's dynamic growth, and especially for its orientation towards memory. More precisely, its power of phylogenetic recapitulation to achieve a new ontogenesis, its desire and ability to delve into both the recent past of American art and the more distant past of its own art history, assimilating both into a new expressive (if not uniformly Expressionistic) art, was recognised

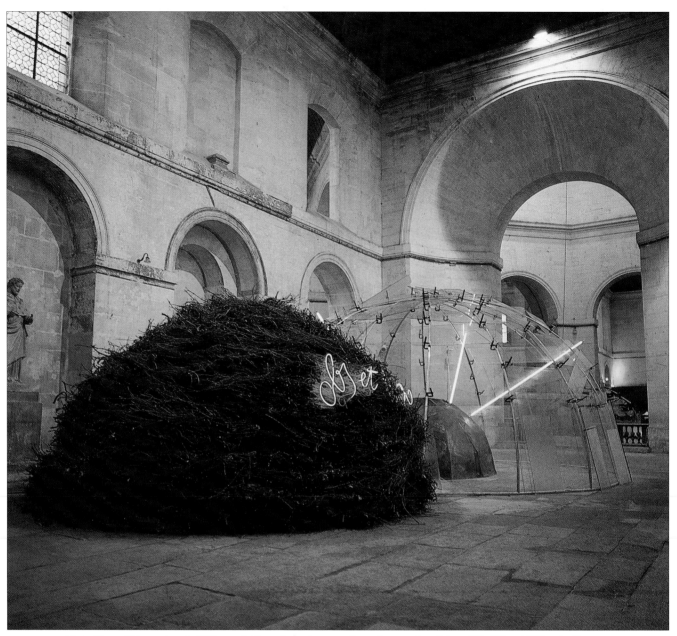

Mario Merz, *Objet cache-toi*, 1985, metal tubes, glass, clamps, twigs and neon tubes, igloos 800, 500 and 300cm in diameter

as pace-setting. Indeed, it was a major articulation of the Post-Modern condition, perhaps in a profounder way than Post-Modern American architecture. European historicism has come to seem very contemporary, and signals the fact that the present is no longer orientated towards a future – no longer as all-meaningful as it once seemed, for a variety of psycho-social reasons (not least of which is the collapse of belief in the Utopian promise of modernity) – but towards the past, discovered to be unexpectedly rich in possibilities. These can be realised by 'poetically' subsuming and synthesising the old modes of production and interest, to create a fresh sense of individuality and novelty. American forward-lookingness/ future-orientation, as it has been called, has been replaced by European backward-lookingness, or respect for the past (which of course always seems to have more dignity, to be more civilised, than the present).

From an American point of view, Europe has always emphasised, or rather meant, oldness, while America was the brave new world, the place of the infinitely expanding horizon of the future. Europe is the place of memory, masked and civilised by the *politesse* of art, but still peculiarly raw – perhaps, as today's

European artists seem to imply, more raw than the American wilderness, from which much American art implicitly took its inspiration. The Europeans know the past is not the dead horizon it appears at first glance to be. Paradoxically, the modes of civilisation – including artistic styles and interests – now seem fresher than nature. This is perhaps why the tide of art has become predominantly European, for Europe has always known how to live with ruins, how to work with and through the past, whose ghost often seems more living than one's body. America has assimilated European art information, just as Europe has assimilated American art information. Each keeps close watch on the other. But the European artist's response to information in general is essentially different from the American artist's response. The American tends to take it as an end in itself, as a structure in itself.

Information and facts are implicitly regarded as one and the same and, as the American typically says, the facts speak for themselves. The problem is to get to them. This remains so even with the widespread recognition of the relativity of fact. The facts are relative, but they must be the case, once a case has been made for them. They supposedly contain their meaning in

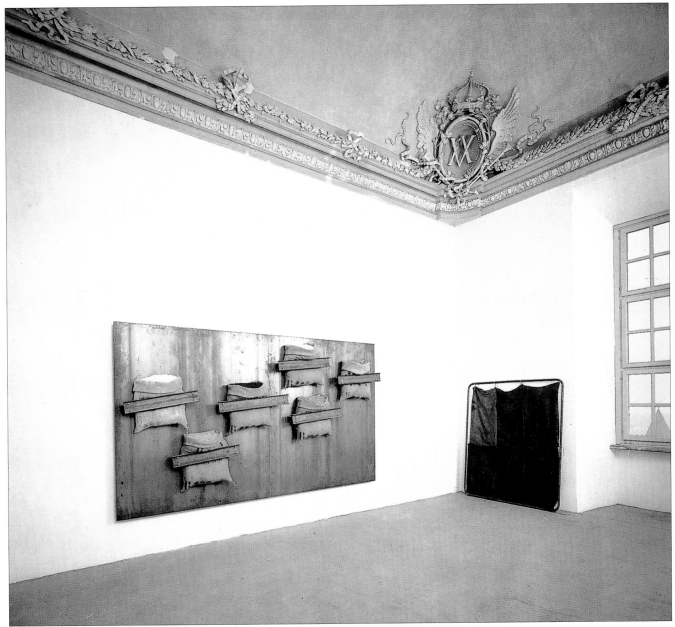

Jannis Kounellis, *Untitled*, 1988, sack cloth, iron and mixed media, 200x360cm

themselves. Moreover, the facts of the past are not related to with any depth by the Americans. They are not reworked, but sentimentalised, in Disneyland style. One cannot imagine an American artist seriously alluding to the American Indian heritage or Melville's dramatic vision of life in the way that Kiefer alludes to Hermann, the barbaric Germanic chief who defeated the Romans, or to Wagner's mytho-operatic vision. To carry this further, for the American, the bacon-strips of information-fact are allowed to fry in their own fat. They are then consumed for their own supposedly inherent testiness. In contrast, the Europeans, to continue the all-American metaphor, tend to fry the information facts in the grease of memory. This gives them an altogether different sense of the taste of the facts, that is, of so-called reality. And this is where the difference between contemporary European and contemporary American sensibility comes in seriously: they have a different sense of reality. (André Breton already said that the sense of reality was the issue of modern art). One can say, no doubt all too simply, that America, for all the difficulties of its current socio-economic situation, for all the pressure of predatory world-wide competition with it, remains optimistic, perhaps cautiously optimistic, but nonetheless forward-looking.

In Europe, for all its post-war prosperity and success, there is an ingrained pessimism, a kind of subliminal negativism, a certain sense of weariness and *déjà vu*, which informs the art. There it is often masked by black humour altogether beyond irony – and/or spiritual (reconstructionist/therapeutic) ambitions. There is evidence of both in Polke, Clemente, Dokoupil, Kounellis, the Poiriers, even Beuys, to mention only what seem the most exemplary cases. There is sometimes a pursuit of the mystique of 'memorableness' as an end in itself, to counteract the weight of historical facts. (I think this is the case in artists as different as Paladino and Kapoor, although it does not exhaust the understanding of their art.) And there is often a kind of insidious theatrical nihilism, nihilism in the garb of contemporary everydayness – a sense of the hollowness of things conveyed through the hollowness of representation, a kind of apathy of representation, an alienated representation (as in Richter and Armleder), which is nihilism at its most nostalgic and narcissistic.

The key point here is that contemporary European artists have a different sense of reality than American artists. The European

George Rousse, *Above*: *Untitled* (Paris, Bercy), 1985, cibachrome, 180x240cm; *Below*: *Untitled* (Geneva), 1985, cibachrome, 180x240cm

artists have internalised the modern idea of the relativity of reality with a vengeance. It suits their sensibility perfectly. Reality for them is inherently untrustworthy; for so history has been, notoriously. More particularly, contemporary reality is invariably understood in relation to past history. (The European instinctively feels there is no other way to grasp it, while the American tends to experience the present as a thing unto itself.) This necessarily changes the sense of both present and past reality. The future is less obviously real in contemporary Europe than in America, or rather, its reality is always tainted by the shadow of the past and the suspiciousness of the present. This is why I would say that the most general quality of contemporary European art – if one wants to make a sweeping generalisation – is lack of forthrightness, calculated equivocation, ambivalence of feeling and ambiguity of meaning, pursued as ends in themselves, rather than as the unfortunate fallout of circumstances. In this, contemporary European art shows how much it retains – has learned the lesson of – the so-called 'obscure' side of early European Modernism, or attempts to re-instate it, perhaps unwittingly. In any case, there is a new obscurity – not obscurantism – for all the Post-Modern sense of the past as 'clear information'. This new obscurity, with its feelings of intimacy and inevitability, is inseparable from endemic European pessimism, with its overtones of cynical self-enlightenment.

A paradox emerges from the contrast of the European and American sensibilities. If, as Baudrillard has said, the hyperreal is 'the generation by models of a real without origin or reality', or the establishment of a state of simulation, then we can say that the American world, and by extension American art, is more hyperreal than the European world. This is exactly because America believes in facts, in the form of information, that is, in hyperreal form. Facts are generated and administered by information systems, that is, models of fact. In Europe, facts are inseparable from memories; the past is unsystematic, or else the ruins of various systems. It is never as intact and closed as a system (of information). We are really badly informed about the past, and it is poorly administered. (Indeed, the past often seems more open, and more available for manipulative reflection, than the present. The rewriting of history is usually more complex and

evocative than predicting the future.) Thus, futility is built into the past, whereas in America, security is built into the past as much as into the future and present, because they are presented in information form, that is, as part of a system of simulated time, which is the American substitute for history and memory. There is no sense of inherent conflict between past, present, and future in America, but rather a sense of continuous development from one to the other. The equivocations of European art – sometimes brittle, sometimes poignant – reflect the conflict between the conditions of time. It is finally the different sense of time that is responsible for the different sense of reality in European and American art. European art today has a more haunted look than American art, indicating a different relationship with the past.

The preoccupation with both its substance and form is pervasive today, but the attitude to it – one might say the ideology of the past – is drastically different. Where American artists – such as those who simulate abstract paintings and the neo-Duchampian specialists in commodity objects (is their hyperreality or simulated reality simply an old irony in the Emperor's new artistic clothes?) – appropriate the past as a *fait accompli*, regarding it as a finished fact, the European artists are themselves appropriated by the past, which never stops unfolding and tightening its hold on the present. Their contemporaneity ends up belonging to the past, which shows not only the power of its hold on them, but the inseparability of their sensibility from it. It is not simply that Europe had to recover from World War II to repair its sense of autonomous identity, but that it had to recover sufficiently free to reflect on the recent past as part of its destiny, and to experience the past as an inalienable part of its identity. It had to recover a primitive sense of being possessed by an irreducible past to make new art. In America, identity and destiny seem much more predetermined, despite the fact that America has less of a (controlling) past than Europe. It is just because Europe unconsciously remains controlled by its past – and self-consciously knows it – that it has once again become the place where the possibility of profound, daring psycho-social awareness remains most alive, as is evident in its new expressive art.

Susana Solano, *Estació Termal*, 1987, galvanised iron, 132x276x276cm

DOUGLAS KELLNER
POST-MODERN ART, ARCHITECTURE AND SIGN CULTURE
A Critique of Jean Baudrillard

Baudrillard began his analysis of art with a discussion of Pop art in *La société de consommation* in terms of the dramatic transformations of art objects in the early 20th century.[1] Whereas previously, art was invested with psychological and moral values which endowed its artefacts with a spiritualistic-anthropomorphic aura, by the 20th century, art objects 'no longer live by proxy in the shadow of man and begin to assume extraordinary importance as independent elements in an analysis of space (Cubism, etc)' (p33). Soon – and Baudrillard likes to move quickly through the terrain of modern art – art objects exploded to the point of abstraction, were ironically resurrected in Dada and Surrealism, then destructured and volatilised by subsequent movements toward abstract art. Yet today 'they are apparently reconciled with their image in New Figuration and Pop art'. (*ibid*)

Baudrillard then raises the question of whether Pop art is an authentic art form of the society of signs and consumption or simply an effect of fashion and thus a pure object of consumption itself. He indicates that the question cannot be answered unambiguously, for Pop art, like advertising, fashion and so on is apparently both. In interpreting Pop art, he argues that it follows the logic of consumption in eliminating representation as a privileged vehicle of meaning (through sign value and exchange value) and, like commodification, reduces the artwork to the mere status of a sign:

> Whereas all art up to Pop was based on a vision of the world 'in depth', Pop on the contrary claims to be homogeneous with their industrial and serial production and so with the artificial, fabricated character of the whole environment, homogeneous with this *immanent order of signs*: homogeneous with the allover saturation and at the same time with the culturalised abstraction of this new order of things. (*ibid*)

Baudrillard raises the question of whether Pop art should be interpreted as a resacralisation of things through the aesthetic investment of art or a banalising of art, a reducing it to a commodity object, to a reproduction of the signs of the commodity world:

> Some will say (and Pop artists themselves) that things are really more simple: they say this because they are taken with them; after all, they are having a good time, they look around and paint what they see, it's spontaneous realism, etc. This is wrong: Pop signifies the end of perspective and the end of evocation, the end of testimony, the end of the active creator and by no means least of all, the end of subverting the world and of iconoclastic art. Not only does it aim for immanence of the 'civilised' world, but for its total integration in this world. There is a crazy ambition here: to abolish the rituals (and foundations) of a whole culture, that of transcendence – perhaps also quite simply an ideology. (p34)

Pop art thus constitutes a turning point in the history of art in Baudrillard's view, the point at which art becomes quite simply the reproduction of signs of the world, and in particular the signs of the consumer society which itself is primarily a system of signs. Triumph of the sign over its referent, the end of representational art, the beginning of a new form of art which he will privilege with his term 'simulation': art as the simulation of models. Baudrillard insists that it is wrong to criticise Pop art for its naive Americanism, its crass commercialism, its flatness and banality, for precisely thereby it reproduces the very logic of contemporary culture, 'and Pop artists could not be reproached for making it evident . . . The worst thing that could happen would be for them to be condemned and so re-invested, with a sacred function. It is logical for an art which does not oppose the world of objects, but explores its system, to enter into the system itself . . . Throughout its predilection for objects, throughout its commercial success, Pop is the first to explore its own status as an art object which is "signed" and "consumed"'. (*ibid*)

Yet Baudrillard sees some dangers lurking in a too enthusiastic embrace of Pop art. For Pop is close to a naive celebration of pure authenticity, bourgeois spontaneity, the authentic artist as the one who most accurately reproduces the world around him or her. Connected with this danger is the 'dangerous aspect of *initiation*' associated with the belief proclaimed by some Pop artists that their art is accompanied by discovery of a whole new world, the world of consumption, full of fascinating new objects and commodities, which serve as inspiration for a new reconciliation with the existing universe. Finally, there is a danger that Pop artists may fall prey to, and thus disseminate: a new essentialism, a new belief that art can grasp and reproduce the essence of things, rather than just reproduce signs. It seems, then, that for Baudrillard, Pop art is valuable mainly as a sign of the logic of consumer society, as a replication of the processes of signification (sign value, abstraction, repetition and so forth) which he was at that time describing on a theoretical level. A similar interest in using art to exhibit his own theoretical positions is evident in the two essays on art in *For a Critique of the Political Economy of the Sign*. The study *Gesture and Signature: Semiurgy in Contemporary Art* illustrates his theory of how the system of objects (and needs) in consumer society is organised into a system of signs. Baudrillard's example is the painting as a signed object (signature) and a gestural object, the product of artistic gestures or practices.

He begins by making the point that in today's art world the painting only becomes an art object with the signature of the painter, with the sign of its origin, which situates it as a '*differential* value' within the system of signs, the series of works, which is that of the oeuvre of the painter (*CPES*, p102). Baudrillard points out that copies, or even forgeries, were previously not denigrated the way they are in the contemporary world, in part because art was more the collective product of artists' studios, and because today art is supposed to be the 'authentic' product of an individual creator as part of his or her oeuvre. 'Modernity' in painting begins when the work of art is not seen as a mosaic of fragments of a general tableau of the universe, but as a succession of moments in the painter's career, as part of a series of his or her works: 'We are no longer in space but in time, in the realm of difference and no longer of resemblance, in the series and no longer in the order (that is, of things)' (*CPES*, p104). It is the act of painting, the collection of the painter's gestures in the individuality of the oeuvre, that is established with the painter's signature which constitutes the sign value of the work as a differential item in the series whereby

the work is inserted into the system of art and receives its place (and value).

Painters like Rauschenberg and Warhol who produce almost identical series of works present 'something like a truth of modern art: it is no longer the literality of the world, but the literality of the gestural elaboration of creation – spots, lines, dribbles. At the same time, that which was representation – redoubling the world in space – becomes repetition – an indefinable redoubling of the act in time' (CPES, p106). In other words, precisely the seemingly peculiar gestures of Pop artists repeating almost identical works in series points to the very nature of modern art, which establishes itself not as a representation of the world, but as a series of gestures, the production of signs in the series of an oeuvre. This practice also points out the naiveté, Baudrillard maintains, of believing that the function of art is to (re)grasp the world, to refresh ways of seeing, to provide access to the real; for such art, all art, is merely a set of signs, the product of 'the subject in its self-indexing' within a series (CPES, p107). Thus, rather than art being interpreted as the product of a sovereign subject who, in the gesture of creation, provides critical commentary on the real or subjective expression, the 'subjectivity in action' in painting points only to the way in which all gestures in the contemporary world are assigned their meaning as gestures within coded series, as part of a homogeneous system of signs, as emblems of everydayness itself, which like the painting, is 'difference in repetition' (CPES, pp108-9).

Thus Baudrillard interprets painting as emblematic of sign culture, of the reduction of culture to a system of signs within which 'art' often plays a privileged role. Art is thus subject to the same rules and system of signification as other commodities, and follows as well the codes of fashion, determination of value by the market and thus commodification. Baudrillard concludes his exercise with a polemic against the very notion of critical or contestatory art:

> Only recognition of this structural homology between a systematised world and art that is itself serial in its most profound exercise permits one to grasp this contradiction of modern art – which is deplored everywhere, even by artists themselves as a fatality. Modern art wishes to be negative, critical, innovative and a perpetual surpassing, as well as immediately (or almost) assimilated, accepted, integrated, consumed. One must surrender to the evidence: art no longer contests anything, if it ever did. Revolt is isolated, the malediction 'consumed'. All the more reason there would seem to be, then, to abandon all nostalgia, resign negativity and admit finally that it is in the very movement of its authenticity, in systematising itself according to a formal constraint, in constituting itself according to a play of successive differences, that the work of art offers itself of its own initiative as immediately integrable in a global system that conjugates it like any other object or group of objects. (CPES, p110)

Modern art, *all* modern art, is thus for Baudrillard an '*art of collusion vis-à-vis* the contemporary world. It plays with it and is included in the game. It can parody this world, illustrate it, simulate it, alter it; it never disturbs the order, which is also its own' (*ibid*). This passage is extremely interesting because it points to a continuity in Baudrillard's work underlying the discontinuities that I have been stressing, in that, up to the present, he has consistently denied the critical and negative function of art and has seen its surrender to and collusion with the existing society as a fatality, a necessity of the current situation.

It is also noteworthy how Baudrillard consistently uses his studies of art to illustrate his theses concerning developments in contemporary society (see, for example, *CPES*, chapters 4 and 5), and throughout the 1970s, he continued to use analysis of art to illustrate his theoretical positions. He frequently referred to Baroque art as a sign of the process of signification transcending representation and as beginning a move toward a self-sufficient series of signs; on the other hand, his frequent references to ultra-realist *trompe l'oeil* paintings were used to illustrate the ways in which simulacra came to replicate reality and the process whereby it became increasingly difficult to tell the difference between simulacra and reality and whereby hyperreal models came to dominate and determine art and social life. He also began writing introductions to art exhibition catalogues and monographs for various museum installations.[2]

His theories of simulation and hyperreality even came to influence new movements in the art world, especially in the 1980s. Indeed, Baudrillard became a major theoretical guru in the world of modern art, a theoretical icon increasingly referred to and cited in discussions of the contemporary art scene. In particular, a trend of simulation art attempted to embody his theory of simulations, while hyperrealist art movements illustrated his theory of hyperreality. A statement by one of Baudrillard's followers, Peter Halley, illustrates his influence:

> One can refer to it as either Post-Modernism or as neo-Modernism, but what is characteristic of this order is that the elements of Modernism are hyper-realised. They are reduced to their pure formal state and are denuded of any last vestiges of life or meaning. They are re-deployed in a system of self-referentiality which is itself a hyper-realisation of Modernist self-referentiality – though it is now detached from the Modernist dream of revolutionary renewal. In Post- or neo-Modernism the syntactical elements do not change. The vocabulary of Modernism is retained, but its elements, already made abstract, are finally and completely severed from any reference to any real.[3]

The new hyperrealist, Simulationist, or Neo-Geo, artists do not attempt to represent any objects or social reality, but simply reproduce hyperreal models or simulations through abstract representations of signs that simulate or pastiche former paintings, abstract and representational, attempt to represent scientific paradigms or models or those of cybernetic languages, or simulate commodity and image production.[4] In the words of art critic Hal Foster:

> Halley assumes a drastic Baudrillardian perspective, according to which our new dynamic of electronic information and mass media has made of social space a total system of cybernetic networks, at all levels of which is repeated one model: 'cells' connected by 'conduits' (thus, according to Halley, the cell-and-conduit system of the computer, of the office with its electronic lines, of the city with its transportation network, etc). It is this abstract field, this putative 'formalism of the cell and the conduit', that Halley depicts with colour-coded rectangles and 'Cartesian' lines, painted iconically on partially stuccoed grounds.[5]

These movements were deflated, but not yet volatilised, by Baudrillard's distancing himself from them during a lecture at Columbia University in the spring of 1987. According to one report, Baudrillard

> sent shock waves through the New York art world when he publicly refused to associate himself with the work of artists such as Peter Halley, Ross Bleckner, Jeff Koons, Haim Steinbach and Philip Taaffe. These artists are identified with so-called 'Simulationist' or 'Neo-Geo' art, one of the hottest new trends to come out of New York in several years. This work has received a great deal of

critical attention, at least in part because it is allegedly based on Baudrillard's controversial analysis of Post-Modern culture. Halley actually claims to provide visual equivalents for Baudrillard's theory.[6]

Evidently, Baudrillard did not like the work with which his theory was being associated, was reluctant to promote any artistic movement, or believed in a separation of theory and art.

In the 1970s, Baudrillard began to refer more frequently to architecture. As a result, his works started being discussed in architectural circles as well. His discussions of architecture, like those of art, were usually to illustrate his social theory, as in the case of his discussion of the twin towers of New York World Trade Center, which was used to illustrate his theory of the new system of deterrence through binary regulation (while the old New York skyscrapers pointed to an earlier world of competitive capitalism with each building – read: individual, corporation, nation-state – aggressively trying to outdo the other. His most detailed analysis of architecture is found in his study *The Beaubourg-Effect: Implosion and Deterrence*.[7] Here, Baudrillard carries out a detailed analysis of the new Parisian Beaubourg culture centre, an ultra-modern multi-storied structure housing art exhibits, films, video rooms, libraries, offices and a lecture hall designed to exhibit all forms of contemporary culture. Baudrillard was both fascinated and appalled by the centre, which he took as an illustration of his main theses concerning contemporary society and culture:

> Beaubourg-Effect . . . Beaubourg-Machine . . . Beaubourg-Thing – how can we name it? The puzzle of this carcass of signs and flux, of networks and circuits . . . the ultimate gesture toward translation of an unnamable structure: that of social relations consigned to a system of surface ventilation (animation, self-regulation, information, media) and an in-depth, irreversible implosion. A monument to mass simulation effects, the Centre functions like an incinerator, absorbing and devouring all cultural energy, rather like the black monolith of *2001* – a mad convection current for the materialisation, absorption, and destruction of all the contents within it. (p3)

Baudrillard uses his analysis of Beaubourg to illustrate in particular his theories of implosion and deterrence. Beaubourg allegedly absorbs and neutralises all cultural energies which implode in a deterrence system that mirrors the political and social systems; thus it illustrates in a microcosm the fundamental processes at work in the larger society. 'Beaubourg is nothing but a huge mutational operation at work on this splendid traditional culture of meaning, transmuting it into a random order of signs and of simulacra that are now (on this third level) completely homogeneous with the flux and tubing of the facade. And it is really to prepare the masses for this new semiurgic system that they are summoned – under the pretext of indoctrination into meaning and depth' (p6). Beaubourg thus really contributes to the death of meaning, to the demise of high culture, and can therefore be seen as 'a *monument of cultural deterrence*'.

Baudrillard thus sees Beaubourg as 'a brilliant monument of modernity . . . the most exact reflection possible of the present state of affairs' (p4). Curiously, Baudrillard is using this piece of architecture as some cultural theorists used art – and Baudrillard, McLuhan and Kroker are three contemporary examples – to reveal the real, to illuminate contemporary conditions, to serve as a privileged vehicle of insight and understanding. In particular, Beaubourg represents for Baudrillard the implosion of culture into the masses and their initiation into a new era of disconnected flow, recycling and massification. Yet while Baudrillard finds Beaubourg highly instructive, he also finds it appalling, for its populist display of culture for the masses 'is, in any case, antithetical to culture, just as visibility and multi-purpose spaces are; for culture is a precinct of secrecy, seduction, initiation and symbolic exchange, highly ritualised and restrained. It can't be helped. Too bad for populism. Tough on Beaubourg' (p5).

Once again, Baudrillard affirms his aristocratic values and fetishes of seduction and symbolic exchange against the cultural populism of Beaubourg. He takes particular delight in reflecting on the phenomenon of the masses of the 'silent majorities' pouring into this cultural centre, filling it up to the point that the very structure of the tubular building was buckling and threatening to collapse. Not surprisingly, Baudrillard finds the whole spectacle exemplary of the implosion of the social and the cultural into the masses, as illustrating his position that the masses were absorbing and neutralising all contents of culture, information, meaning and so forth, just as Beaubourg-Thing was supposedly neutralising cultural energies. Indeed, in his most amusing thesis, Baudrillard claims that rather than seeing Beaubourg as a work of cultural mystification of the masses, 'the masses fall on Beaubourg to enjoy this execution, this dismembering, this operational prostitution of a culture that is at last truly liquidated, including all counterculture, which is nothing but its apotheosis . . . *the masses themselves will finish off mass culture*' (p7).

Indeed, Baudrillard claims that the real content of Beaubourg consists of the masses themselves, whose programmed flow through the museum replicates the flow of energy, information and goods through networks of social life. Indeed, the models of culture in Beaubourg point to the ways in which social (simulation) models produce the very massification of the masses:

> Everywhere in the 'civilised' world the buildup of stockpiles of objects entails the complementary process of human stockpiling: lines, waiting, bottlenecks, concentrations, camps. That's what 'mass production' is – not massive production or a utilisation of the masses for production, but rather a production *of the mass(es)*. The mass(es) is now a final product of all societal relations, delivering the final blow to those relations, because this crowd that they want us to believe is the social fabric, is instead only the place of social implosion. *The mass(es) is that space of ever greater density into which everything societal is imploded and ground up in an uninterrupted process of simulation* (pp8-9).

The masses go to Beaubourg to see a painting, a film (or other people – who cares?). Baudrillard goes to see the masses. The masses see objects and people. Baudrillard sees implosion, deterrence and simulation. This ability to see one's categories instantiated in various domains of social life is both the talent of the theoretician and a mark of sign fetishism, of seeing signs – of one's theory or whatever – where other people see things, events, humans and so on. It is also remarkable how Baudrillard is able to identify with these masses – who are 'ourselves (there is no longer any difference)' (p6) – and to read their secret designs and thoughts. 'The people want to accept everything, swipe everything, eat everything, touch everything. Looking, deciphering, studying doesn't move them' (p10). Henceforth Baudrillard will be the mouthpiece of the masses, giving voice to the silent majorities and to the things themselves, enlightening us as to what is really going on, speaking for the abused yet seductive object world. The social theorist of the society of signs and simulations will soon become the metaphysician of the new world into which we are entering.

As he turned to metaphysics, Baudrillard soured a bit on art, believing that it had exhausted itself and might not have much to offer (which did not keep the art world from enthusiastically pursuing him as a prophet and privileged mouthpiece). In the

interview 'Game with Vestiges', Baudrillard claims that in the sphere of art every possible artistic form and every possible function of art has been exhausted. Furthermore, against Benjamin, Adorno and other cultural revolutionaries, Baudrillard again claims that art has lost its critical, negative function:

> Truly, art can no longer operate as radical critique or destructive metaphor. So art at the moment is adrift in a kind of weightlessness. It has brought about a sphere where all forms can co-exist. One can play in all possible ways, but no longer against anyone. There is no longer an enemy, no longer any system . . . Of course, there is still one, but it no longer has the specific power of, for example, capital or the political in their hey-day. Accordingly there is a disappearance of the horizon of a political order, a cultural order. It amounts to this: art is losing its specificity. It is brought back to itself again in a kind of self-reference and it continues to operate in all its tableaux. That is to say, it is becoming 'mosaic' as McLuhan put it. It cannot do anything more than operate out of a combinatory mode.[8]

Baudrillard then describes the Post-Modern as

> the characteristic of a universe where there are no more definitions possible. It is a game of definitions which matters. It is also the possibility of resuscitating images at the second level, ironically of course. It all revolves around an impossible definition. One is no longer in a history of art or a history of forms. They have been deconstructed, destroyed. In reality, there is no more reference to forms. It has all been done. The extreme limit of these possibilities has been reached. It has destroyed itself. It has deconstructed its entire universe. So all that are left are pieces. All that remains to be done is to play with the pieces. Playing with the pieces – that is Post-Modern. (p24)

Baudrillard thus argues, rather contentiously, that all possible art forms have been produced, as well as attacked, revived, deconstructed and put back together in combination with other forms. All the targets of oppositional art, he claims, once again highly dubiously, have been destroyed so that art has lost its power of negativity – of negating what exists – and of effectivity. All art – and presumably theory, politics and individuals – can do is to recombine and play with the forms already produced. As he put it at the end of the interview:

> Post-Modernity is neither optimistic nor pessimistic. It is a game with the vestiges of what has been destroyed. This is why we are 'post' – history has stopped, one is in a kind of post-history which is without meaning. One would not be able to find any meaning in it. So, we must move in it, as though it were a kind of circular gravity. We can no longer be said to progress. So it is a 'moving' situation. But it is not at all unfortunate. I have the impression with Post-Modernism that there is an attempt to rediscover a certain pleasure in the irony of things, in the game of things. Right now one can tumble into total hopelessness – all the definitions, everything, it's all been done. What can one do? What can one become? And Post-Modernity is the attempt – perhaps it's desperate, *I* don't know – to reach a point where one can live with what is left. It is more a survival among the remnants than anything else. (Laughter!) (p25)

Notes

1 Jean Baudrillard, *La société de consommation*. The study of Pop art in the book was translated as 'Is Pop An Art of Consumption?' in *Tension*, 2, 1983, pp33-5; subsequent references to the translation cited in text.

2 References to art abound in Baudrillard's major texts. He has also written art catalogue introductions and monographs including studies of Jean Revol, Barbara Kruger and others.

3 Peter Halley, 'Essence and Model', programme notes to *International with Monument* exhibition, New York, nd.

4 Hal Foster, 'Signs Taken for Wonders', *Art in America*, June 1986, pp 80-91. Foster provides a survey and critique of current Baudrillardian trends in the art world.

5 *ibid*, p139.

6 Grant Kester, 'The Rise and Fall? of Baudrillard', *New Art Examiner*, Nov 1987, pp20-23. Kester notes a Jan 1987 'Anti-Baudrillard' exhibition, and provides some all too rare criticisms of his theories and influence on the art world.

7 Jean Baudrillard, *The Beaubourg-Effect: Implosion and Deterrence*. Subsequent page references cited in text.

8 Jean Baudrillard 'Interview: Game with Vestiges', *On the Beach*, 5 (Winter 1984), pp19-25.

Peter Halley, *Prevention Mechanism*, 1989, Day-Glo acrylic, acrylic and Roll-A-Tex, 195.6x328.9cm

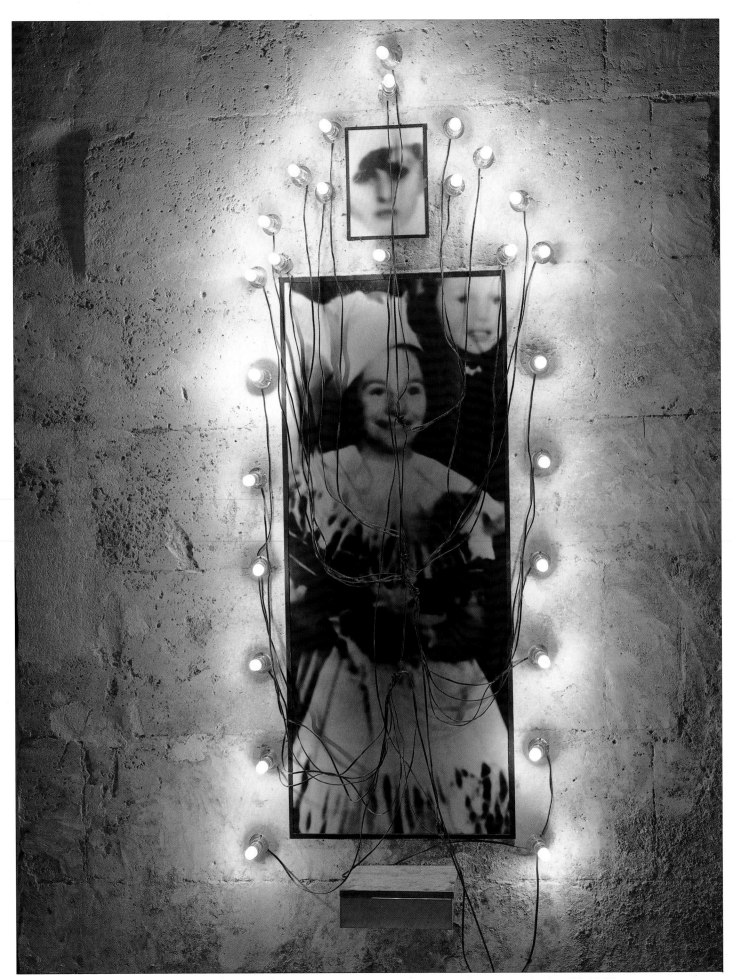

Monument (Odessa), 1989, metal box, black and white photographs, 27 bulbs and sockets, electric wire, 150x45x23cm

CHRISTIAN BOLTANSKI
IN CONVERSATION WITH LYNN GUMPERT

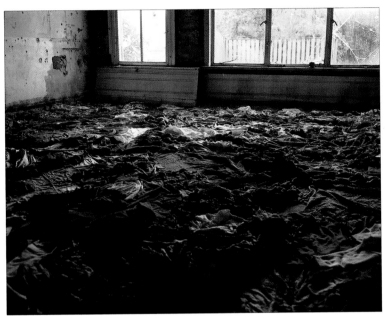

Untitled, 1988, used clothing installation, 1500x500cm

I first met Christian Boltanski in November 1985 when, as Senior Curator for the New Museum of Contemporary Art in New York, I travelled to France by invitation of the French Ministry of Foreign Affairs to view contemporary art. I vividly remember an evening visit to the suburb of Malakoff, to meet Boltanski. In his studio, part of a complex of factories renovated by a group of artists as live/work spaces, I saw odd arrangements consisting of photographs of children and flowers in tin frames surrounded by small light bulbs. They were, I was to learn, experimental installations for a new series that would be titled, Monuments. *I found them extremely moving, redolent of a host of associations that reverberated with surprising intensity. I was also amazed by the breadth of work Boltanski had amassed. A few days later, Mary Jane Jacob, then Chief Curator at the Museum of Contemporary Art in Chicago, and with whom I was travelling, likewise ventured out to Malakoff. She, too, was impressed and we decided to organise jointly an in-depth solo show. As part of the preparation for this exhibition, which was titled* Lessons of Darkness, *we jointly conducted a lengthy interview with Boltanski in June 1987. This was only one of a number of conversations I subsequently had with him. Later, on the occasion of the extensive tour in North America of* Lessons of Darkness, *there was ample opportunity to discuss both his work and his ideas about art and life with him. Discussions and interviews, I realised, are one means by which he crystallises current concerns and where he reiterates key ideas crucial to his work. In preparation for my essay for the exhibition that opened at the Whitechapel Art Gallery in April 1990 (and which subsequently travels to the Stedelijk Museum in Eindhoven and the Musée des Beaux Arts in Grenoble), I interviewed Christian Boltanski, again in his Malakoff studio, where I quizzed him about his recent works. An excerpt from that conversation follows.*

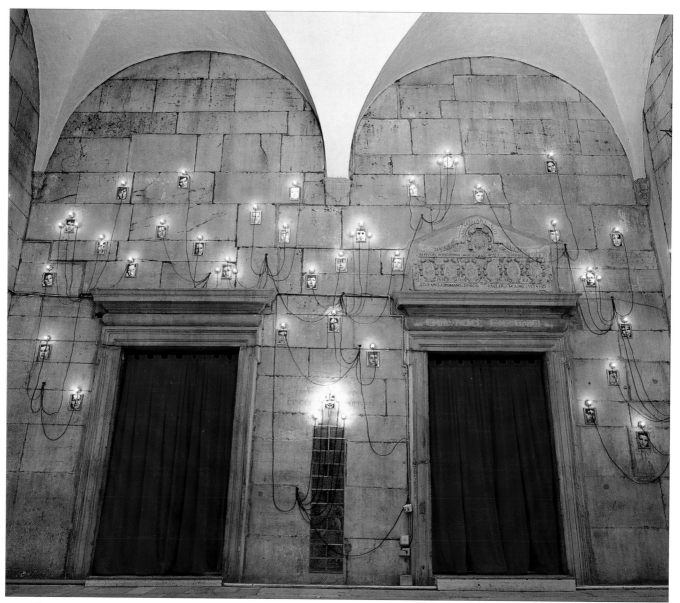

Monument: Les Enfants de Dijon, 1986, 140 photographs and approximately 300 lights, installed at Palazzo delle Prigione, Venice Biennale

– Why do you think people respond so emotionally to your work?
Because they don't respond to it as art; they don't even pose the question whether it is art or not. What struck me a lot about my exhibition tour in the US and Canada, was that I had very strong emotional responses from the cleaning ladies and guards, as well as from the critics. That is to say, my work really appeals to the general public. And this isn't necessarily positive. In an interview not too long ago, I compared myself to the French film director Claude Lelouche, who is a very bad one. There is a side of my work that is 'Chaplinesque', very sentimental.
– I agree. You have to be careful to maintain a balance.
Yes, it is very dangerous. People often see only the side that is very sweet. They say 'Oh, the poor children . . . Oh . . . Oh!' But there is another aspect of my work that isn't so evident, which is the seller of cadavers. I earn my living, as it were, with cadavers. I have also been thinking about Pasolini, a filmmaker who I like very much. Last spring I saw again his film, *Salo*, which is based on a novel by the Marquis de Sade. It is really the most difficult film I have ever seen; afterwards, I needed to walk alone outside for an hour. By simply viewing it, you participate in criminal activities. And this interests me. For example, I recently made this little book consisting of rephotographed corpses of murder victims as a special edition for *Parkett* [a Swiss art journal]. When looking at it, the viewer becomes a participant in the crime

– they become criminals. I try more and more to mould people so that they too become responsible. I also understand that for me, for my work, my obsession with death is very unhealthy and immoral. American critics didn't see this at all. Moreover, I take a strange pleasure in this. And if I capitalise on this aspect, it is because, no doubt, I have a tendency to be a murderer. It is part of understanding myself, of accepting this in myself and, at the same time, of pushing it away. In any case, I have the feeling my work is more and more bizarre. I take a bizarre pleasure in imagining all these people dead, for example the 3,000 people who are pictured in the piece *Les Suisses Morts* (1990).
– When do you think this obsession with the dead began? When you were little?
I don't know. I think it is very linked to this idea I have of objectification . . . It is very strange to me that someone who is alive, who has a memory, can be hit on the head and instantly become a dirty object that can be manipulated. And like this little book for *Parkett*, the pictured cadavers don't belong to anyone. The dead are objects; that's why I am both horrified and fascinated by them. Because they are objects you can torture . . .
– There is now a discussion in the US about the rights of the families of the victims since they suffer each time an image of the murdered victim appears in the newspapers or on television.
I understand. I did ask myself a lot of questions when I made it –

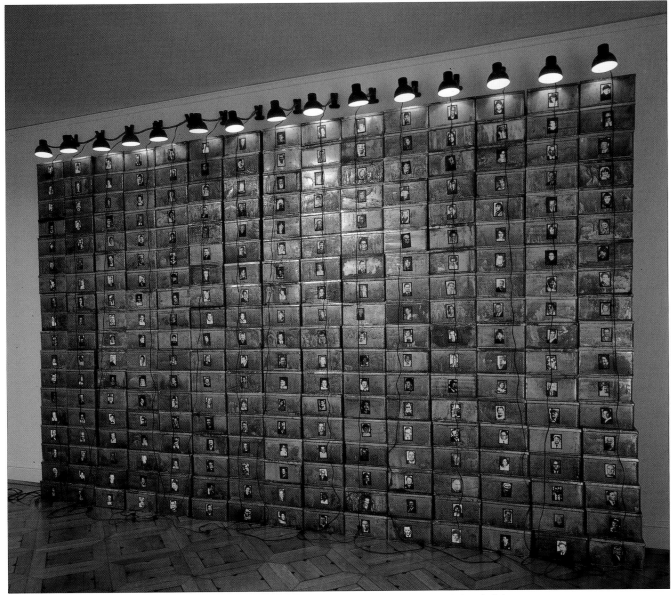

La Réserve des Suisses morts, 1989, metal sheets, photographs and electric lights

because there is a very disgusting, creepy side to a piece like this. You know, I have always said I didn't like at all the works of Robert Morris when he used images of the concentration camps. Although I got these photographs from this Spanish newspaper, to use them again is a sort of new rape . . . And it is different for the people who place them in the newspapers. They might remember them as they were, as opposed to me who uses them for something else, things that I sell, that I show in a museum . . . But the most shocking thing about this piece is that these are photographs of real people. If they were painted, it wouldn't upset you as much. The appalling aspect is the connection with reality. But at the same time my work is also false, manipulated.

– *This brings me to the theatricality and formal manipulation in your work, for example, light; the fact that your most recent installations are always in darkness. And you use real people, like in theatre.*

Yes, but actors aren't real when they act. They interpret. I made a book a long time ago, *Quelques interpretations de Christian Boltanski* (1974). I photographed myself drinking a glass of water in front of a curtain. It was captioned: 'Christian Boltanski interprets the role of a man who drinks a glass of water.' The audience, when they see you drink a glass of water, recognises the sensation of being thirsty. But if you drink because you are

thirsty, it is because you really are thirsty. But if you are an artist, and you drink, others recognise and remember the fact of drinking. But actors exaggerate so that the audience feels the sensation of being thirsty more strongly . . .

– *Yes, but that is where art and the art of theatre overlap. Theatre is also an art.*

Yes, it is theatrical art. The deceptive part of my work is theatrical: it is artificial, an enlargement of reality. The fact that the *Parkett* book is very small is part of the artifice. But at the same time, it is an artifice which is given as real. In the theatre, the director I respect the most in the world is Tadeusz Kantor. It is theatre which perhaps doesn't have a text just as my theatre doesn't have a text. Kantor said in an interview that his work is intended to make people cry. I also know how to make people cry and I am content when they cry. And Kantor also uses exaggerated means. This is not always good. For example, he will suddenly play music so loud that it hurts the ears. Or he suddenly shines a very bright light – all to provoke emotions, which is our shared goal. Some things that I do can appear very simple, easy: I want to reach a large public. So, even when I use means that are easy, if I succeed at what I want to, this is good. But it is at the same time very dangerous, and a little ambiguous. For example, by making the room dark, people naturally lower their voices . . .

– *But if one enters into a museum, one knows this is a different*

27

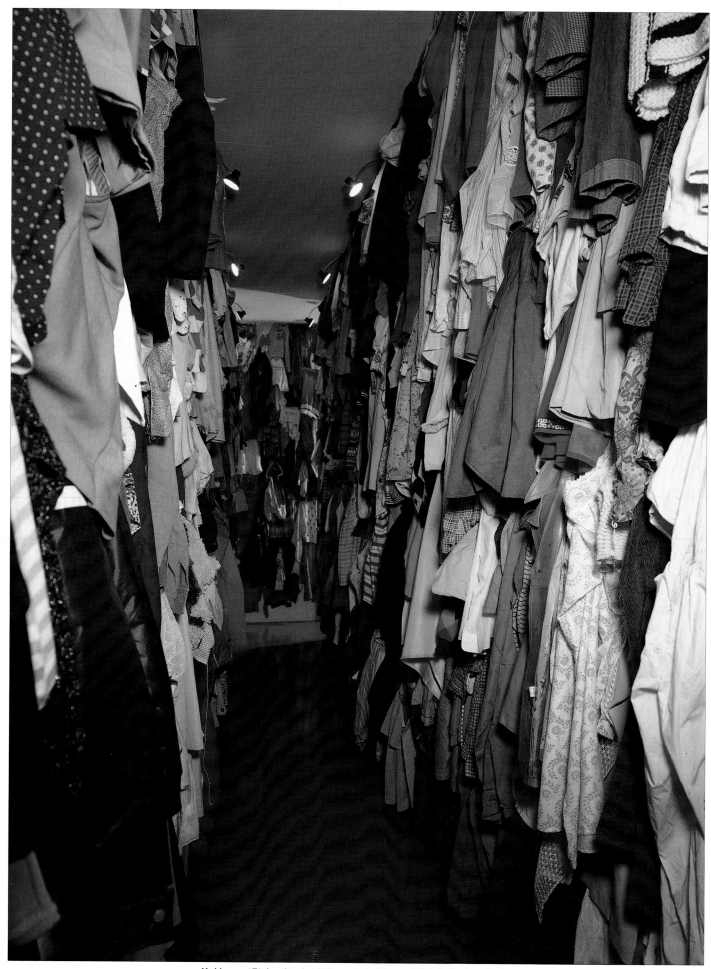

Hahbourg 'Einleuchten', 1989, used clothing and lightbulbs installation

reality.

It's ambiguous. You know very well that it is art. But in spite of everything, the emotions are good because they are real.

– Do you think this is due to the fact that you are using photography?

In part, but not totally. For example, when I use clothes and the photographs in my work, there is a relationship implied between these clothes and the photos. But in reality, the clothes are new and the photos are old. Yet people tend to think of the clothes as relics. But I am not a complete liar because I always make sure to emphasise that the clothes are from the present. For example, if there is a tee-shirt with a Batman logo, I put it in front so that it is clearly visible. But at the same time, psychologically, for those who are looking at it, there are these connections.

– Let's talk more about the clothes. Why did you decide to work with them?

What is evident is that clothes and photography are exactly the same thing. With both there is the idea of absence. A photograph was someone and now it is no longer anyone. And with clothes, there was someone, and now there is no longer anyone. In both cases, there is also the idea of the memory of the subject in the object. With a piece of clothing, there are still the folds, the odour of the subject; yet at the same time, it is an object. And the photograph is the memory of the subject which has become the object, encased in the frame, but really just fragile materials that will become dust . . .

– What I find so compelling about your work is that it can be read on many different levels; emotionally and intellectually.

It is a little like the cinema. When you are there, you cry. Then when you come home, you discuss the plot, the film angles, etc. There are many levels and I know this. I am always conscious of what I am doing, even if I make mistakes, which could be negative.

– But there is also the very formal aspect of your work as Serge Lemoine pointed out in his essay in the catalogue accompanying your 1984 retrospective at the Centre Georges Pompidou.

Surely. I am certain of this. But I always have difficulty about speaking about the formal side of my work since I don't have training in formal theory. But I was nourished on the very formal, Minimal work of the 1970s. For example, the biscuit boxes are not unlike the Minimal boxes of Donald Judd. But they are also psychological things which send you back to your childhood and memories of biscuits. They can likewise remind you of where you store the ashes of the dead. If these boxes were made of steel, they would have a totally different effect. I use a Minimal vocabulary, but at the same time, I try to use things that people recognise or photographs that carry psychological connotations.

– Another important aspect of your work is the use of everyday objects, for example, clothes or lamps.

Yes. And the emotions that are evoked are in response to these real things. They are like the photographs of real people. Yet they are used in very artificial ways. For example, one would never find so many desk lamps in an office. But I intentionally play with this ambiguity. Because really I am a liar. People think that I find all these rusted tin biscuit boxes, but I really buy them new and then make them old prematurely. And this is a deceitful thing. I tell people, 'This is the truth, not art.' I let people think that my work is real, but it is totally art . . . Part of the strength of Joseph Beuys' work, which was a big influence for me, is the way he used real objects. For example, if he put a broom in a vitrine, the broom had been used to actually sweep in an action or performance. All the objects in Beuys' oeuvre are there because they are souvenirs of things that had a function. With the unhappy students I teach, I always tell them to be sure everything they make has a function. Not necessarily a practical function,

but that each component serves a purpose. I want my work to be functional or have the air of being functional, and I am sure that comes from both Beuys and from Fluxus. It shouldn't be art for art's sake or art by chance, but art that functions as art.

– This brings us back to the notion of theatre and theatricality in your work, the artificial means you use to manipulate emotions. The real false, 'le vrai faux'. It is very complicated. When I made this small book for Parkett, *I wasn't really sure why I made it. I made it in part because I was afraid; I knew it was not a nice thing. It was something I had to do, but at the same time, I was disgusted by it. There is a whole side of me where I classify things, but there are also many things that I don't know. I am certainly much more pessimistic and depressed than five years ago when you first met me.*

– Is this true? I thought that you were much more depressed in your youth, when you first began making art.

I don't know. Perhaps, but I don't think so. It is very bizarre. Certainly, I am becoming much more professional in my work. And I am receiving a lot of attention and admiration. But at the same time, I feel I am more and more sombre. And I do many things without a strategy, without a specific goal; I can't say why I do it. I am attracted to things without knowing why, perhaps because they are the most obscure.

– But at the same time, it is important not to over-analyse. You said earlier that you're very aware of what you are doing for the most part, but there are also things you can't know, and this is more interesting, I think.

It is true that it is better like this. That it is not too simple, not black or white.

– What are the things that make you happy now?

To try to make a good piece.

– That pushes you to make other new works?

Maybe this is not healthy, but I increasingly believe that this is what really motivates me now. You know that I always say that one lives less and less the more one works. I still believe it. But at the same time, there are always new things to figure out. For example, to lose your parents is a very strange thing. Because you are then the next to die. What is certain is that the more you live, the more death is awaited. I live with my own death constantly. Clearly this is always something that has been close to me, a game perhaps. But now it is a lot closer, something I wait for every day, that I prepare for. You know that I am not at all religious; but I find it harder and harder not to be religious.

– Another thing that I find interesting in your art, and which is related to the Parkett *book, is that people do buy your work. Even with all the overtones of death. And they put it in their homes.*

It is completely crazy! I am really a swindler, a kind of Rasputin. People need a sort of false sanctity. They need some kind of relics . . . I think that the current situation for contemporary art is very dangerous, one which can even destroy art. Artists are more and more corrupted by this situation, even the best artists. And I believe that I am corrupt, that I participate in this. There can be good artists only if there is a morality (which is not a morality about not drinking or smoking), but a sort of goal that goes beyond the market and art fairs. A goal that is mystical or political, that has a rigorous moral nature. That is my 'dada' now, what I am thinking about. The artists of my generation, of the 1970s, we were Utopians. And what is happening now in Eastern Europe and China is very serious, it is the end of a Marxist Utopia. The whole 20th century was marked with this idea. Good or bad, it was so. And as we approach a new century, the current Utopia is the idea of 'golden boys', of money. And this is a very unhappy and destructive situation.

– It is the end of a hope for Utopia, then?

It is terrible that one no longer exists. And I think it is better to have a bad or stupid Utopia than not at all.

Bertrand Lavier, *Mirior No 7*, 1989, acrylic, gold paint and glass, 138.5x77cm

GERMANO CELANT
UNEXPRESSIONISM
Art Beyond the Contemporary

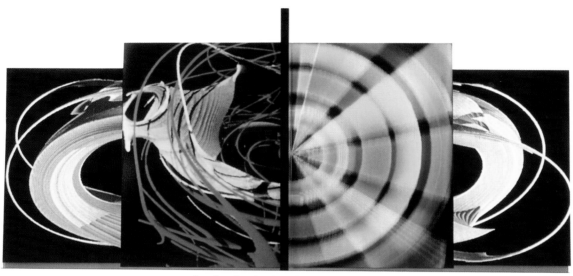

Gretchen Bender, *Untitled*, 1989,Type-C print

Coming to terms with the accelerated history of an artworld obsessed with the new, Celant recognises the difficulty in attempting to articulate or define the present. Perceiving the significance of the negative, the anonymous, and the lack of 'originality' in new art, he evolved the term 'Unexpressionism'. In this extract from his text, he expands his theory, establishing a definition for 32 new artists.

Unexpressionism is not devoted to the contemporary, it does not believe in its ritual simplifications. Rather, it is so profane and sceptical that it sets out on the road of non-being. It prefers interfering with the cold and empty condition of currency, wherever the horizon of 'new' experience and its originality has descended. Conscious that today originality serves as a promotional element yet does nothing but keep reiterating the same aspect;[1] Unexpressionism is not interested in opposing knowledge with inspiration and invention. Instead, it moves through the field of appearance and its application. It draws attention to the fraudulence of languages, including that of art. It does not perform, it strips itself naked. It flaunts its paradoxes between entities of meaning and meaninglessness. It presents itself virtually 'all at once' without legitimising any conclusion. It enunciates the substances of the contemporary, but does not wish to justify or judge them, much less indicate which lines to follow. It is thought of not as a solution, but as a 'symptom' with an absence of traumatising use and debasement of language, and with a serene and almost neutral recourse to what exists.

The Unexpressionist totalities investigate the forms of arguments applied in all fields of seeing and constructing. They work in and with the media, as languages that have no subject because they are applied to all subjects. They reveal their artifices and techniques of persuasion, they verify their universality and

autonomy. Hence they work upon the rhetoric of advertising, photography, movies, architecture, and design in order to examine their figures and genres and make their eloquence obvious. However, the assemblages are not functional, not goal-oriented; they are emblems of an elaboration aimed at exposing the workings of systems which adulterate and counterfeit the image.

They draw strength from the failure of quotationalism to create the new, and they lucidly analyse the reasons that have produced the dead centre, where, for the crisis of invention, verisimilitude and verity, copy and original are one and the same. In these terms, they try to establish an anti-rhetorical attitude. Thus, if Neo-Expressionist painting is based on the mannerist excesses of the image, Unexpressionist art studies the cold and geometric arrangement and assembly of things and apparatuses without dissimulating technological artifice; it seeks the meaning of the communication technologies such as advertising and photographic reproduction, which are available for any use whatsoever and utilisable for any goal whatsoever. In this sense, Unexpressionism looks at the Baroque, its cold marble forms, which become alive and palpitating ***Jeff Koons** lucid and rigid masses, in which rhetoric or the art of persuasion makes them passionate and impassioned, elegant and graceful. The intent is to show the 'exercises of ingenuity' contained in the 'neutral' images,[2] whose simulated and theatrical appearance is

not accidental, but constructed in terms of mechanisms and technologies.

Devotion to and mannerist deformations of the sacred image of Art and the Contemporary are replaced by a non-subjective presentation and an overall situation that evince the theatrical and cinematic character of the present. **Marco Bagnoli** In other words: by juxtaposing and constructing artificial images, the Unexpressionist artists reconnect the contemporary to theatre and cinema, offering art as a 'stage' practice in order to define it as a hypersensitive instrument of persuasion. Their inventions on paper and film, on canvas and the screen, in the environment and with things, make the artificial speak in the artificial, the image in the image, and the reproduced in the reproduction. Their works are a representation of twofold fiction and construction: they exploit the typically Baroque idea that life and the present are nothing but spectacle and simulation.

We must also point out that if an artwork uses the show-business media and rhetorical effects, resorting to billboards or neon signs that can display the processes of persuasion and invention applied to planning visual communication, this artistic attitude revives discourse and criticism. It speaks about images and its technologies, about its laws of mimesis and artifice; it distinguishes those images, and in this case it seems to go back to the conceptual assumption, although developing it by using the image against the image. Unexpressionism adopts a practical – rather than a discursive or written – demonstration for figures and objects, spaces and contexts. It does not resort to logical models or abstract philosophical arguments. Instead, it makes abundant use of small models and stage-sets, **Juan Muñoz** plans and designs, substituting the practical image for speech, while pursuing a commentary on the means of communication.

For Unexpressionism, being a 'conceptual Baroque' signifies critique and parody, a displacement and a construction/deconstruction of economy and information, consumption and ideology of the languages of the public and the mass media. It assumes a judgement on their functioning and their foundations, squandering them, that is, making excessive and over-abundant use of their materials and technologies. Indeed, the overall Unexpressionist approach is excessiveness. It stages things and figures that are located at the centre of the environment, enunciating a spatial geometry, in which art is no longer a tapestry, but an architecture, a real place, based on the pleasure of building and constructing.

The preparations and elaborations of the Unexpressionists are limitless proliferations; they play non-stop with the object or the lost image – a sensual and artificial game that has no aim other than waste and squandering, visual luxury for the sake of pleasure. Hence, they go back to smooth bodies, covered with industrial glazes and plastic **Jan Vercruysse** laminates, dazzling opaque materials, refined surfaces and textures, meticulous and chiselled craftsmanship, almost as if produced by a goldsmith or designer, engraver or conjuror, in order to 'define' a smooth and sparkling world, polished and marmoreal, like our everyday life.

By means of the play of balance and imbalance, the grafting and multiplying of thingly bodies, whether heavy or light, the Unexpressionist totalities are translated into constellations of clouds and stars, moons and rainbows that rotate at unequal speeds. They rise and fall, **Niek Kemps** they intertwine playful and voluptuous movements, negating their rigid reality.

These cosmologies trace the possible co-ordinates and potential laws that rule the contemporary. They are understood as ensembles of values and representations, of models and behaviour at a given moment of society. They are totalising visions of the present, syntheses in which every aspect is integrated in an articulate and structured system.

Gerhard Merz, *Untitled* (from *Io Son Architetto*), 1988, pigment, linen, 40x14c

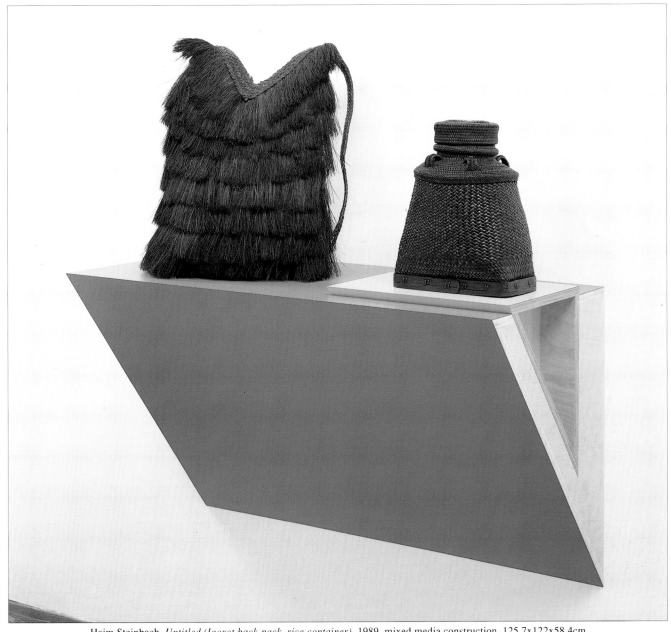

Haim Steinbach, *Untitled (Igorot back-pack, rice container)*, 1989, mixed media construction, 125.7x122x58.4cm

capable of a flat reply: a surface of lights and shadows, on which a reflection, rather than being fixed, glides over the cold and compact body.

With its reflection and its radiation of light, the Unexpressionist's object reflects its aura upon the environment and the surrounding architecture. It establishes a journey – we are always dealing with the rapid transit of images – that radiates out, touching the external. The reflection can come with artificial light as well as the light of natural colours, **Remo Salvadori** which wraps up instruments and furnishings, paintings and sculptures, studios and galleries in a translucent sheath. For the Unexpressionists, the process of colouring is developed on fullness. More than suggesting a third dimension, more than being an irregular materiality of lumps and oils, powders and pigments, their colour is generally mechanical, reflecting the vitality of printed colours. This process is neither natural nor organic, it translates a transmission of chromatic information. It is a red, a yellow, an ochre, a black, a green, a false gold – from the printer's book of colour samples. It is the essence of colour, with no history or emotions – so much so that it can give life to things. It connects with figures and objects, **Allan McCollum**

forming and composing them. It is a minimal discharge. It claims an autonomous dimension of the language of advertising and television. It implies reproduction, dislocation, and being *en route* without claiming any link to any one image over another. It conveys a notion of 'travelling through'. It superficially dresses things in light and seems to incorporate things by virtue of its crude and dense luminescence. Its visual charge does not separate from a weightiness and a certain gravity that exclude every internal fermentation and levitation; yet it liquefies and anchors things to the ground. Colour is not content to promote a visual modification of objects and surfaces; it turns forms upside down, triggering their maturation as full entities. By ripening them, it swells their smooth epidermis, and this stage indicates a previous stage in the succession of routes.

Thus, the theme of transit and crossing is frequent in the Unexpressionists, and they evoke it with such subjects as the station, the monitor, the subway, the page, the billboard, and the supermarket counter. These are places of acceleration and deceleration in which the everyday continuum is measured as are its changes and interruptions. They configure time and the halting of images, which run at an intense speed.

ALLAN McCOLLUM

Surrogates on Location, 1982-89, photograph from TV

'My first impulse was to make only one painting and exhibit it over and over again, to create a sort of archival object – like the government's Bureau of Standards maintains the standard "inch" in platinum. But this solution eliminated the possibility of exchange transactions – and how could a thing represent an art object if it couldn't be bought and sold? I ultimately decided to use a single but repeatable image, one which I could vary minimally in size and proportion, but which remained essentially the same: a frame, a mat and a black centre.'

artist's statement
'Before I ever actually made any *Plaster Surrogates*, I was always seeing them on television, on the walls behind the actors. But they were only fleeting images, like accidents of light, or mirages. What I was recognising, I guess, was an image which was only just potentially developing inside my head. So when I ultimately began to physically create these objects, to cast them in actual plaster, and to produce them by the hundreds, it was always very mysterious to me which image I might honestly point to within this chain of representations as the *original* "surrogate".'
'Considering the range and potency of the feelings we all have for industrial production, it continues to be a surprise to me that artists never want to utilise industrial production in their work. They will *allude* to the mass-produced object, through imagery, but

These are dynamic exhibition galleries, in which the signs glide by at a steady rhythm, devoid of ground supports. Actual jet engines hurl all sorts of things into the void: particles of light and sound, virtual images of synthetic communication. Yet we must remember that the terminal of these systems is the human body. The reader or viewer, that is, the personnel assigned to transmitting and receiving, has eyes filled with data and information. These eyes are a territory covered with communicational reflections, clad in marks and electronic impulses. Thus, the texture covering the body is a further transit space for the distinctive signs of industry, advertising, and television. It is swaddled **Rosemarie Trockel** in colours and logos, acquiring the screen traversed by the evidences and appearances of the contemporary. The era of nudity is over and done with: the surfaces of bodies are semblances and fashion masks, as well as monitors and means of circulation they are covered with stitches or fabrics, but such outer trappings convey figurations and industrial insignia, in the latest fashion. To conclude: Unexpressionism moves simultaneously with the swift propagation of the notions and fissions of the contemporary; it is triggered by an accelerating escalation, in which particles and photons, electrical

and electronic impulses occupy the 'non-place' of mass vision. Unexpressionism tries to refer to the hypersensitive field of advertising and telecommunications and it confronts its limits and its degree of velocity. Co-existing with its endless presence, Unexpressionism begins to sense that art now risks losing its central role and becoming an uncertain and decentralised joint and screen displaying images of discarded and recycled things. In order to flee an uncontrolled and overwhelming vertigo, Unexpressionist art introjects the essential ties to these systems of appearance and artifice. It uses them to camouflage itself and it assumes the role of critical and deconstructive interpretation. It declares itself available to mediated behaviour and to the unexpressive mentality in order to seek its autonomy in the planetary system of artefacts and manufactured products. It emancipates itself not in the original, but in the copy of the copy, **Richard Prince** in the reproduction of the reproduction, in the simulacrum of the simulacrum, in order to keep pace with communicational repetitivity. And in order to achieve this result, Unexpressionism adjusts to becoming a sophisticated and precise technology, alert to its mode of artificial production. It calculates its projectivity and its geometric and volumetric

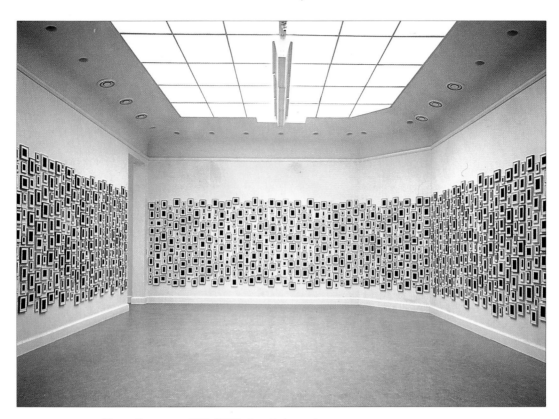

Plaster Surrogates, 1989 (1982), installation at Serpentine Gallery, London 1990

not through any actual replication of thousands of things. In our era, we have great powerful ambivalence towards large numbers. We're afraid of how there is more in the world than we can ever know or understand, more human souls than we can imagine, and so forth: hordes of people, hordes of machines, hordes of information. But we are also completely infatuated with exaggerated quantity, with the possibility of abundance and plenitude, with wealth, and with our fantasies of perpetual fecundity, and so on. It's amazing that art completely stands aside of all this drama, preoccupied with its own scarceness, with its own uniqueness. I think that possibly we create art the way we do in order to *avoid* our feelings about these issues.'

interview with Selma Klein Essinck

'I think that there must be something false about the desire to look at a picture; it couldn't possibly be something we are born with. It must be something we grow into, like the way a dog comes to desire such a strangely contrived activity as being taken for a walk on a leash ... My paintings and drawings don't serve a proper function – how could they? They're only representations, props, and surrogates: not real paintings at all. If I can engineer this charade the way I want, I think I can transform the seemingly innocent act of looking at art into a slightly nightmarish duplication of itself.'

artist's statement

routes. It no longer relies on accident and spontaneity; instead, it banks on the sciences and technologies. Having to operate in a space and time 'without dimension', because it is propagated and multiplied by electronic means that fuse and confuse, create and recreate figures and objects at an uncontrollable rhythm, Unexpressionism no longer operates on contemporary time; rather, it seeks to transfer its production 'beyond time' and 'beyond space'. This 'producing beyond' has nothing in common with the communicational present, in which high and low, first and last, past and future, back and front exist. It has more in common with the ultrasonic speed that passes into the ether, confusing temporal chronologies and spatial topologies. It goes beyond the present and the past, beyond the contemporary and the future. This 'beyond' is not metaphysical; it is physical on the microscopic scale of the nuclear and the photonic. We can therefore be at the ultimate vigil and vigilance of art, when the contemporary vanishes into the infinitesimal in order to continue to manage the depth and complexity of images, whose transmission will be momentary, whose representation will be precarious and whose passage will be very brief. Nevertheless, a lost condition will not help to find another one, equivalent to the wave length of contemporary vision beyond the contemporary.

Notes

* The insertion of artists' names into my text is not tied to an interpretation or description of their work, even if it opens up correspondences between ideas and images that strike me as interesting. These insertions are a way of leaving the dialectics between the parts open, interweaving them, interrelating them, without forcing them to illustrate one another. The territories run parallel, but they look at one another and, as in the book, they reflect one another.

1 Marc Jemenez, *Adorno: Art, Idéologie et Théorie de l'Art*, Bourgois, Paris, 1973, p75.
2 Severo Sarduy, *Barocco*, Editions du Seuil, Paris, 1975.
3 Giulio Carlo Argan, *Immagine e Persuasione*, Feltrinelli, Milan, 1985, p108.
4 Paul Virilio, *L'Espace Critique*, Bourgois, Paris, 1984.

SHRIEK WHEN THE PAIN HITS DURING INTERROGATION. REACH INTO THE DARK AGES TO FIND A SOUND THAT IS LIQUID HORROR, A SOUND OF THE BRINK WHERE MAN STOPS AND THE BEAST AND NAMELESS CRUEL FORCES BEGIN. SCREAM WHEN YOUR LIFE IS THREATENED. FORM A NOISE SO TRUE THAT YOUR TORMENTOR RECOGNIZES IT AS A VOICE THAT LIVES IN HIS OWN THROAT. THE TRUE SOUND TELLS HIM THAT HE CUTS HIS FLESH WHEN HE CUTS YOURS, THAT HE CANNOT THRIVE AFTER HE TORTURES YOU. SCREAM THAT HE DESTROYS ALL KINDNESS IN YOU AND BLACKENS EVERY VISION YOU COULD HAVE SHOWN HIM.

Jenny Holzer, offset paper poster from *Inflammatory Essays*, 1979-82, 43.2x43cm

BROOKS ADAMS

'INTO THE WORDS'

Thoughts on A Forest Of Signs

Barbara Kruger, *Untitled*, 1989

'Photo: Ceci est la couleur de mes rêves' (Photo: This is the colour of my dreams) reads the inscription on a 1925 painting by Joan Miró, seen recently in The Dada and Surrealist Word-Image *at the Los Angeles Contemporary Museum of Art. Taken figuratively, the Miró seems to anticipate the feeling and content of* A Forest of Signs – *the large group show of contemporary artists, many of them*

working with both photography as well as word-and-image, that was recently on view at the Temporary Contemporary. The Miró, using a single patch of dreamy blue in conjunction with the hand-written phrase, expresses, in a seemingly effortless way, the poetics of modern revery. It does not insist on a 'crisis of representation' as the *Forest of Signs* show did; in fact, it rather breezily seems to imply that no such crisis exists. The Miró does draw our attention to several conundrums, such as the fact that this is a painting of a photo and not a photo itself, or that words function somewhat differently from colour, or that the idea of a black and white photograph in the 1920s cannot quite be equated with the colour blue, that epigone of both Symbolist and Surrealist dream states. But none of this is experienced as 'crisis', and neither, I would maintain, is much of the work included in *A Forest of Signs*.

According to Richard Koshalek, Director of MOCA, the show focused 'on the central artistic issue or "crisis" of our time: the meaning of art in a media- and consumer-influenced era, and the meaning of representation within this art. The title of the exhibition refers to the "forest" of signs and symbols that define contemporary culture: the flow of images from films, billboards, bus benches, magazines, television and art itself that are with us daily. These images have come to represent a new reality in their own right – a reality that we seek to enter and imitate in our own

lives.' In her catalogue essay 'Art in the Age of Reagan: 1980-1988', Mary Jane Jacobs (co-curator of the show with Ann Goldstein) points out that: 'the relation of today's art to consumer society is perhaps even more complicated that that of the Pop artists. The subject now is not a product pulled from a grocery shelf, but art itself as a product for sale. Appropriating techniques of commerce and advertising for the content, mode of fabrication, and presentation of the work, artists are playing with strategies of both the business and art worlds that have combined forces in so many ways over the past decade. As a result their work stands somewhere between criticality and complacency.'

Now whether any artistic issue can be considered central to the global concerns of today is highly debatable; the very concept of centrality suggests a colonialist approach, or better yet, a neo-colonialist approach to art and to art criticism. It strikes me that the meanings of art are always multiple at any given moment (and for any given viewer), and it also strikes me to call any artistic issue, even in quotation marks, a 'crisis' is pushing it, to say the least. Whether it be a flashy polychrome sculpture by Jeff Koons, or an incisively funny paperweight by Louise Lawler, or a strangely inscrutable narrative by Larry Johnson, which proves difficult to read because of the jazzy colours it is printed in, the contemporary art in *A Forest of Signs* all represents a sold link to art of the past, be it the Baroque art

Installation view showing works by Jeff Koons and Robert Longo

that has so clearly influenced Koons, or the 60s dot paintings that seem to inform Johnson's photographs. The obvious links with 70s Conceptual art, discussed by Anne Rorimer in a catalogue essay 'Photography – Language – Context: Prelude to the 1980s' have prompted many people to call this kind of work 'neo-Conceptualist' or even 'neo-70s'. Many have made the point that the exhibition was visually impoverished, in fact, that 'this was the show you didn't even have to see in order to review it'. Yet to my eye, there was plenty to look at in *A Forest of Signs*. In fact, many artists' decisions to work site-specifically produced works of unique impact at the Temporary Contemporary. The show was full of amazing *coups de théâtre,* such as Jenny Holzer's soaring wallpapered stripes of brilliantly coloured pronunciamentos, which formed a backdrop for Allan McCollum's equally breath-taking tabletop display of 10,000 individually cast, peach-coloured plastic hand grenades. The installation also had a subtle visual logic to it. The gridded order of Holzer's placards played off the implicit organisation of McCollum's objects, not to mention the soft grid structure of Gretchen Bender's mammoth *People in Pain,* a series of heat-set vinyl panels illuminated with the white neon titles of every movie that came out in 1988. Thus,

for better or worse, these works make use of 60s Colour-Field and 70s grid thinking – changing and, in a sense, historicising it in a hip and knowing way. Holzer uses the grid structure to break down any hierarchical readings of her work; we can scan it top to bottom, side to side or a panel or a sentence at a time.

The issue of legibility is a complex one which deserves some discussion. Do we enjoy Larry Johnson's gay narratives any less because they are hard to read? Isn't the difficulty part of the content? Or how about if we just enjoy the Jenny Holzer for the colour of the stripes, Richard Prince for the neo-Ed Ruscha palette, or Sherrie Levine for the framing and faux-wood grain-ing? So common have most of these works become on the international art circuit that we are almost obliged to look at only one level in them per viewing, or rather, to look for a new level of meaning at each viewing if we are not to become impossibly jaded. Thus much of this work can seem to take on the monotony of 'official' art. Yet to read a part for the whole, especially in the enormous pieces of Bender, Holzer and McCollum, makes for a kind of necessary visual synecdoche – one might even call it a survivalist synecdoche. This kind of fragmentary visual experi-ence never seems to bother us when we're looking at ancient

44

Installation view showing works by Allan McCollum, Jenny Holzer and Gretchen Bender

sculpture (where some parts are usually missing) or Impressionist painting, with its radical croppings of figures and landscapes, and it certainly doesn't bother us when we're watching TV.

As for visual fragmentation, Jeff Koons' polychrome sculpture *Woman in Tub,* with its sawed-off head, can be made to seem like the latest model in a venerable tradition of sawed-off sculpture, beginning with ancient ruins and extending to Degas' bronzes. Similarly, Louise Lawler's mysterious photograph of museum floorboards which reflect Frank Stella's protractor paintings on the wall might even have a subliminal source in Gustave Caillebotte's *The Floor-Scrapers* (1875), not to mention Sylvia Plimack Mangold's 70s paintings of floorboards and mirrors – one of the many ghosts of recent art that flicker, seemingly unnoticed, through *A Forest of Signs.*

Many of the artists in the show seemed to be preaching a new American sublime of absolute size and sheer number of parts (*viz* Holzer's and McCollum's installations), and the size of the TC allowed some artists to work especially big. A more traditional landscape sublime was evident in Jack Goldstein's early 80s panoramic paintings of lightening fields, themselves seemingly dependent on an old *Artforum* cover of May 1980 illustrat-

ing Walter de Maria's *Lightning Field* at work in New Mexico. Coming at the end of the 80s, a renewed fascination with the sublime, and the overpowering effects of artistic or natural scenery, may be one road out of sterile, art critical casuistry.

The exhibition also espoused an architectonic sublime – an art of building signs that uses very simple, reductive, visual means to express some readily understandable architectural function, with a new, expiatory or Utopian twist. Ronald Jones' very expensive-looking stone floor pieces, which embed the plans of American internment camps in the floor of the Temporary Contemporary for what seemed eternity, struck me as an almost pharoanic enterprise – one which nevertheless has roots in Carl Andre's 60s and 70s floor pieces, as well as more anonymous and popular monuments such as the celebrity footprints at Mann's Chinese Theater. Jones' piece was intended to remind the public of crimes perpetuated against the Japanese during World War II. Matt Mullican's signs and symbols, on the other hand, often seem to be postulating some *Brave New World* city planning on a par with Le Corbusier – only now with an ironic edge. Mullican's signs are all immediately legible and comprehensible, which sometimes makes them less than fascinating.

Above: Barbara Bloom, *The Reign of Narcissism*, 1988-89, mixed media installation; *Below*: Mike Kelley, *Pay for your Pleasure*, 1988, installation view

And Richard Baim's slide show *Turn of the Century* captured the feeling of the world's fairs past and present, expressing a nostalgia for the future that was also one of the hallmarks of the show.

The paradoxical use of photography was clearly a binding element, insofar as none of the artists seem to practice photography as a fine art. Barbara Bloom's inclusion of her dental X-rays and horoscopes printed on to fabric which was used to upholster faux-period chairs in her Neo-Classical room called *The Reign of Narcissism* constitutes a novel, or perhaps a very archaic, use of photography. Bloom almost seemed to be taking us back to the era of daguerrotypes, and her signed handkerchiefs on sale in the bookstore were a nice neo-Victorian touch. Christopher Williams' decision to label his black and white photographs of old glass flowers at the Peabody Museum with the names of countries that currently practice terrorism had a kind of Baudelairean logic to it; these really did become 'Flowers of Evil', an idea already implicit in Robert Mapplethorpe's photographs of 'fatal' flowers. Like the biting commentary behind Bloom's temple to the self, Williams' photographs become updates on the *vanitas* theme in Dutch painting, exposing the mortality, and in this case, the terrorism, behind seemingly pretty and innocent images.

Many artists seemed obsessed with the aura of the page, be it the intense charisma of printed stationery, newspapers, or even hand-written letters. Stephen Prina's decision to reprint a 1969 Lawrence Weiner word piece *A Translation from One Language to Another* on 61 pieces of specially designed stationery in as many languages (58 of which were exhibited in a long line at the TC), deals not only with appropriation but with a kind of endless theme and variation of a simple 'module' of language (Weiner's original piece). Here Prina literally incorporates one of the father figures of Conceptual art into an 80s corporate letterhead from the Berlitz translation house in Woodland Hills, California that produced the project. All of this seems doubly ironic in light of the current revival of interest in Weiner's work, which in the late 80s can summon up images as unlikely as Dutch landscape in its succinct 'horizons' of words.

Prina's appropriation also brings to mind the pranks of Marcel Broodthaers, the Belgian poet and Conceptual artist, whose retrospective at MOCA provided any number of toney European precedents for the work in *A Forest of Signs*. Broodthaer's anodised aluminium version of Mallarmé's poem *A throw of the Dice* (1969), expressed as so many abstract bars of a certain length, seems particularly prescient of Prina's works, which often deal with the masterpieces of world art in terms of their relative dimensions. This kind of super-dry Conceptual wit would, no doubt, have been appreciated by Broodthaers, whose *La salle blanche,* a reconstruction of the artist's apartment in Brussels with words painted all over the walls, became at MOCA *the* 70s precedent *par excellence* for *A Forest of Signs*. Indeed,

coming across a small image of a dog looking at a dolphin floating above him in *chien souffrant de la solitude* (dog suffering from solitude) of 1975 with the caption, 'Die Crise? . . . Ein Traum' (The crisis? . . . A dream), I was reminded once again of that epithet 'Art in the Crisis of Representation' and was tempted to see in the Broodthaers a solution, or at least a precedent, for the problems that *A Forest of Signs* posed.

At its best, the show offered many such paeans to visual literacy. Mike Kelley's *Pay for your Pleasure,* a rainbow bright corridor of famous artists' and writers' portraits and their quotations on how art is somehow above the law (for example Jean Genet's 'I want to sing murder, for I love murderers'), worked like a refresher course in graduate school high seriousness. Yet, by adding artwork by the so-called 'Freeway Killer' William Bonin at the end of the corridor as well as a donation box at the entrance, whose proceeds went to Local Victims' Rights Organisations, Kelley brought real-life concerns into the sacred precinct of high art. Here for once we seemed to encounter a genuine crisis of representation for, without the donation box, Kelley's piece might seem to extol crime as well as romanticise real-life murderers. Yet for all its so-called dire subject-matter, this piece, not unlike the Miró, could be experienced as an upbeat, joyful, even celebratory rite of passage. As in the Holzer, the zowy Colour-Field stripes belie the dour sentiments expressed. Like it or not, Kelley's veritable spectrum of a corridor has as much to do with the conventions of Minimalist painting, California light art and Bruce Nauman's corridor sculptures of the 70s as it does with Baudelaire's *Flowers of Evil.*

Kelley's piece, like Bloom's, succeeded in creating a mini-environment, a kind of museum-within-the-museum, that in fact becomes a simulacrum of the museological experience, such as we also find in Broodthaers' work. His *Musée d'Art Moderne, Départment des Aigles* (Museum of Modern Art, Department of Eagles), a vast Conceptual project that entailed loans of art and curiosities on the subject of eagles from museums around the world, seems to announce the spirit in which so many artists in the show are working today. As Broodthaers noted in a famous quote, explaining how he became an artist: 'I, too, wondered if I couldn't sell something and succeed in life. For quite a while I had been good for nothing. I am 40 years old . . . The idea of inventing something insincere finally crossed my mind, and I set to work at once.' Yet even this posture of insincerity does not exactly cause a crisis of representation. It may cause a crisis of conscience, as it seems to have in Kelley's case, but then again, it may serve as yet another rallying cry for the artists in *A Forest of Signs*. Many of them succeeded in creating just this sort of fictional, one-person archaeological cabinet, or rogue's gallery – much as if the TC were some sublimely Brontësque, deserted English country house that we had discovered – chock-full of dusty 1980s memorabilia.

Larry Johnson, *Untitled (I had never seen anything like it)*, 1988, Type-C Print, 115.5x228.6cm

Buster Keaton, 1988, polychromed wood, 167x127x67.3cm

JEFF KOONS
THE POWER OF SEDUCTION
An Art & Design *Interview*

Ushering in Banality, 1988, polychromed wood, 96.5x157.5x76.2cm, edition of 3

Interviewed in London towards the end of 1989, on the occasion of his talk at the ICA, Koons reflects
on his commercial success within the consumer-dominated art world of the 80s. Seeing the influence
of the mass media as exercising a positive effect on the artist's power to communicate and seduce an
audience, he discusses issues such as exploitation, political effectiveness and the concept of the new.

– Glancing through the abundance of 'Jeff Koons' interviews and statements from the 80s, the issues constantly under discussion range from art as a commodity, the art 'industry', the power of the market, political effectiveness and exploitation, to advertising, information networks, communication devices and entertainment. Do you see your art primarily in these terms?
My own interests are in many of the areas which you mention. I believe that it's very important for art to be effective in communications. For a very long time art has not been very effective and artists have not taken the responsibility to communicate. Of course, when anything like this occurs, when one political network or one industry defers its responsibility to communicate, other industries that do feel responsible and are ambitious will take control of that industry. We've seen this occur with the advertising industry and also the entertainment industry; they've been much more effective in communication than the fine arts. I would like to do everything possible to assist in returning this responsibility to art, to manipulate and seduce an audience and to communicate effectively with them. In doing so, it's a responsibility not only to exploit oneself, which one must do – artists must exploit themselves – but to exploit others, to communicate with them in order to meet their needs and to be the great communicators.
– When you talk about communication and effectiveness, what

ideas are you aiming to communicate and in what ways are you as an artist being effective?
First of all I've been very interested in trying to help liberate people so that they can participate in social mobility; social mobility and education is always a dialogue within my work. My art is really there to help keep people out of equilibrium and to enable them to participate in mobility. My work tries to embrace everyone, to educate the lower classes in how systems work and how one can be effective within a system, thereby giving them a chance to exploit themselves.
– So, by appropriating familiar images from the mass media, from advertising, pop music etc, images which break down the boundaries between gallery-exhibited art and everyday consumerism, you are aiming to communicate to a mass audience?
I believe in using imagery that is familiar. I hope that people will be able to embrace my work and to communicate with it. I hope that somewhere I will break down a wall so that they will participate and just give in to the image, saying 'Okay, you know you've got me.' Even if they are very resistant, at some point they will let their resistance down. My work tries to describe what the parameter of life is. I want it to have the sudden sense of familiarity because it is not about formalism. This is not subjective art, it is very objective, and in this aspect I want my pieces to really erase themselves as far as form is concerned and

the amount of space they take up. They're really about everything that is just invisible, that's in the air, that's ephemeral perhaps. It's about things that people are maybe familiar with in a post-card shop or just in some aspect of their life.

- And by confronting viewers with familiarity, you are forcing them to abandon their inhibitions about art and about what art 'should be'?

I'm trying to help liberate people, to remove inhibition and to let the individual be as loud as possible, to remove people's fear and guilt and to let them know that all the great things in the world-to-come are already here. Nothing new is ever going to come here, it's just going to be the transformation of what is already here. It's like making a new chemical compound, it's putting different associations together and really great, wonderful things appear. Only the things that will come are already here and if people look they will be able to liberate themselves and will realise that ultimately their state of being is becoming. Everything is here and everyone can just become.

- While your aim is to communicate to a mass audience and to break down social barriers, the inevitable criticism is that your art isn't in fact accessible to a mass audience; it is exhibited in commercial gallery spaces so that, rather than communicating to the child in the street, for example, you are only really seducing the fashionable art-going élite.

Although my dialogue is above all with the adult community, the child in the street is a living human being and represents our future. I absolutely want to be having some dialogue with our future. I embrace these people just as I would embrace someone who is much older, who is part of a generation that has preceded my generation. The dialogue is the same. I try to function within my art and the vocabulary is really about eternal things. I'm not interested in the surface of things and certainly not in fashionable trends or anything of that kind. I do not involve myself in that sort of thing. I'm involved in what my ideas are and in what I think is important to myself and I try to lead in the best manner that I can.

My interests are very tied up in my own vocabulary. I'm interested in trying to liberate art, in trying to make artists ambitious again so that they take on the responsibility to participate and to assist in breaking down some of the walls so that they can experience their own culture. Artists don't want to show that they're victimised and of course one must be victimised to be able to absorb one's culture and to participate. And one also has to take the responsibility as far as leadership is concerned. It is about governing and communicating and one must communicate in any way that is possible. My work will do absolutely anything to communicate. My work will say that it is speaking in any dialogue the viewer wishes to hear, just to be able to start a communication. I believe that once a communication process starts, my political intent will be transferred to the viewer.

- In your conscious manipulation of the mass media and your attempts to seduce an audience by displaying familiar consumer objects and ready-mades in the context of a commercial gallery, to what extent have you been influenced by the example of Warhol and the Duchampian concept of art?

I am absolutely a product of Marcel Duchamp; I come out of the Duchampian period. So did Andy. Andy is like a child of Marcel and I'm like a grandchild of Marcel. Of course Marcel was the one who, mostly along with Braque and Picasso, liberated everyday things and the use of collage, be it newspaper or some other material. Marcel introduced the object into art and Andy followed through in the use of that object. However, one of the things I so respect in Warhol isn't so much his use of the familiar and the ready-made, because Marcel had already ploughed through that, but rather it is the aspect of sexuality in his art.

Warhol was able to communicate intellectual information, not through a cerebral process, but through a sexual process and this is why I have so much respect for Andy. As far as my own role is concerned, I believe that I started to add to the Duchampian philosophy and to create a new ground when I did my work called *The New*. This was an encased work displaying vacuum cleaners for their newness; that is displaying an object for its integrity and for being brand new. It dealt with the negotiation between the animate and the inanimate, with the positive aspects of the animate alongside the positive aspects of the inanimate. It's part of reading something that's in a position to be immortal; it's a kind of ultimate state of being, of being eternally new. My work continues to deal with ultimate states of being.

As far as participating in the media, I believe in total co-ordination. It's very important to do everything one can, not to hurt oneself but to be able to help oneself. In a political power situation, to be able to communicate with people through the media is wonderful. The media is a phenomenon of communication, that is something that should be embraced, whether you're using aspects of envy or whatever to communicate and stimulate the public. It's all very positive and you must use everything that's available to the best of your ability. I think that the intent of the media is to communicate and to deliver the information at hand. Of course nothing's ever that perfect but I don't think that working with the media is any form of compromise at all. I think that it is very positive.

- Frederic Jameson has described the New York art world in terms of 'perpetual change', highlighting the transience of artists operating in a market that is constantly demanding 'the new'. Is there a need for artists to 'liberate' themselves from the commercial system to a certain extent?

I think that artists must deal with this situation and I think that it is very important for young artists to be able to defend their independence from the system. One has to understand the system, to be independent of it, or to participate with it. You always have to be in control. If you feel that you're not in control of the situation, then you have to be able to divorce yourself from it. A lot of artists feel too insecure, particularly if they have had success without ever having being able to claim their independence. I've been very lucky in that I did claim my independence.

I participated with the art system when working with galleries such as Mary Boone, although I didn't enjoy the experience that much because it wasn't really a time when my ideas could penetrate. There is a network and once this network of dealers and writers and critics and collectors starts to focus on one area, then they just want to concentrate on that one area for quite some time, to digest the information that's there. I realised that my ideas were just not really going to have a chance to participate at that moment and, instead of sitting on the sideline and moping, I decided to go out and take care of my own work. I didn't have to participate in the commercial art world. I had a responsibility to my work. I worked as a broker down on Wall Street to support my art. My work was expensive to make but I had a responsibility to continue making it. In this way I was prepared, when the environment was better, to have my political stage. The environment at that time was looking in a different area. However much I might have yelled 'Hey, look over here!', at that moment it was too focused on something else. But as soon as I could see that the environment was changing and looking for something new, I showed my ability to lead.

The art world is by no means unique from other professions such as acting or stockbroking. One can rise to a certain level of notoriety and then fall; that happens everywhere. But of course if artists are good, then they can maintain themselves and can continue to participate.

I think I have done substantial work which has helped contrib-

LAURA TRIPPI

THE STRANGE ATTRACTION OF CHAOS

The ideas embedded in the language and images of chaos science strike a familiar, strangely seductive chord. Like the shapes and figures of its 'fractal' geometry, our daily experience is fragmented, fraught with randomness and arbitrary juxtapositions. Patterns of perception and social practice are assaulted by an onrush of information. 'Reception', Walter Benjamin wrote as early as 1936, is 'in a state of distraction, which is increasingly noticeable in all fields of art and is symptomatic of profound changes in apperception . . .'[1] Under the pressure of new computer and video technologies, we seem to be undergoing a *quantum leap* in the state of distraction identified by Benjamin as a perceptual effect of the rise of film and photography. Leisure time, work, and art, our bodies and so also ourselves – all are absorbed into the breathing and buzzing sureality of simulation culture, global information networks and cybernetic machines.

'Chaos Science' is an umbrella term for two related and flourishing fields: fractal geometry and the study of complex dynamical systems. If its computer-generated video graphics, with their images of a randomised geometry and of systems in chaotic states, strike in us a sympathetic chord, perhaps it is because of our immersion in an atmosphere turbulent with new technologies. The guiding myths and models of modernity have been hopelessly infiltrated and frayed, and even the once invigorating concept of 'crisis' itself seems to have collapsed. This is a journey into space – the 'phase space' of turbulence and 'sensitive dependence'; of 'multidimensional degrees of freedom', of the decay, creation, and random fluctuation of information. In the allure of chaos science lies a search for the strangely *fractured* fairy tales of an emerging apperceptual and technological regime.

Border Skirmishes

Benoit Mandelbrot's compendium and guidebook, *The Fractal Geometry of Nature*, was published in 1983. In 1985, Goethe House, New York, sponsored the first exhibition of fractal graphics, produced by scientists and offered in unaltered photo-reproductions as art.[2] By the mid-80s, the shapes and formulas of fractal geometry had begun to appear in the work of practicing artists. But forces other than the discourse of science seem to have prepared the ground for the expropriation of its latest images and ideas.

A new branch of geometry, the study of fractals, breaks with the Euclidean tradition of idealised forms, relying instead on fragmentation and irregularity. With an infinite nesting of pattern within pattern, repeating across scales, fractal images open onto an area devoid of fixed coordinates. Because the mathematical operations that produce fractal 'landscapes' depend on the introduction of chance (random number generation), each repetition of a given pattern asserts a fractional difference from all others. The notion of boundary, too, is confounded. On closer look, the line dividing two regions reveals unexpected complexity. Instead of a clear line of demarcation, one finds an endless regress of detail: surfaces that give way on inspection to more surface, boundaries that never resolve.

As Post-Modernism, Post-Structuralism, multi-cultural questionings of the canon, feminism, post-linear historiography, and now even a post-Euclidean geometry, wreak havoc with received habits of thought and practice across a variety of fields, a picture of cultural rupture presents itself, patterned and pockmarked by the 'border skirmishes' of a boundary that refuses to resolve.[3] But forces other than those of discourse *either* in the sciences *or* in the arts would seem to have prepared the ground for such a cultural rift.

Figuring Phase Space

Complexity science is to time in the physical sciences as fractal geometry is to space: in the terms of Thomas Kuhn, a 'revolution', an exchange of operative paradigms.[4] With its concentration on the properties of fluid motion, it joins together fields whose common theme is the study of flows of information – weather patterns, population growth, epidemiology, prices on the international exchange, but also brain waves, the pumping action of the heart, stellar oscillations. All are *open, dissipative* systems, meaning that they take in energy from outside which leaves in the form of heat, and that they generate *entropy*, the measure of disorder that accumulates.

Like fractal geometry, complexity science relies on computer technology to produce its simulations of physical systems. *Phase space* plots the successive states (or phases) of a system in an abstract *multidimensional* space, with as many dimensions as a given system has *degrees of freedom* (heat, speed, viscosity, for example). A point in phase space represents the total state of the system at a particular point in time. With a dramatic increase in the value of the variable(s) driving the system, its course through phase space can suddenly leave the *limit cycle* (or *periodic orbit*) marked out by the system during a stable state. This phase transition marks the onset of turbulence, where prediction proves impossible. The turbulent system will never visit the same point in phase space twice, but traces an intricate path, careening through a region that gradually, surprisingly, begins to take shape. The system has found what is called its *strange attractor* and entered a chaotic regime.

Concentrating on phase transitions, the study of dynamical systems notes a more or less abrupt change of behaviour as some parameter – degree of freedom – reaches a critical value. Linear temporal flow is translated into a figural dimension. Wrapping infinite difference into a bounded region of phase space, the strange attractor twists and jumps and creases endlessly, not tending toward a final culmination. It could be said that if the system seems to *jolt* or *explode* from a periodic orbit into a chaotic regime, once it has reached the wider region that describes the limit of its strange attractor, it *implodes* as it 'settles onto' its new orbit, exhibiting an oddly compelling property of stable instability, predictable unpredictability, determinate indeterminacy: deterministic chaos.

By an alternate means of computer diagram, complexity science finds that this leap from a stable orbit to a chaotic regime leads through the scenario of *period doubling*: points of stability

Zoe Leonard, *Untitled*, 1988, black and white photograph

become unstable as the value of a given variable is raised, and split into two. At a critical juncture, the period-doubling reaches an extreme degree and gives way to the *bifurcation cascade*, the threshold that marks the onset of turbulence. 'Chaos is spontaneously generated, creating randomness from purely deterministic origins.'[5] In phase space, an elegant, filigreed structural stability emerges: the strange attractor. Bifurcation diagrams, however, give a different twist to the story. Once the system has entered a chaotic regime, windows of order arise spontaneously. In the midst of entropy, a self-ordering principle appears. The tendency of dissipative systems toward ever-increasing disorder is off-set by intermittent calls to order, emanating from *within* the very horizons of the chaotic.

Deterministic chaos offers a model of change for which our current vocabulary is conspicuously lacking: development, evolution, advancement, progress, even unfolding (though this seems to approach the idea), all carry with them the sense of a final cause toward which each intervening event tends. Other than these, we have digression, deviation, deflection, departures, swerves, and lapses – terms to which the French intellectual historian Michel Foucault looked for describing what, in the action of history, he called 'the singular randomness of events.'[6]

The Coming of Urgent Indeterminacy

If such ideas, presaged by Henri Poincare's 1903 study, *The Three Body Problem in Celestial Mechanics*, announced a 'revolution' to science of the 60s, the notion of determinate indeterminacy was already informing compositional practice in the arts by the late 50s.[7] The work of John Cage, in particular, is exemplary in this regard. In his lecture on 'Indeterminacy' of 1958, the horizon of the aesthetic arena was characterised by a bewildering onslaught of demands, of information and new technologies, with a corresponding transformation of regular, measured time into a plastic, even spastic flow.[8] By now, the state of technology has drastically changed. In the place of Cage's almost quaint 'telephony', we have *telecommunications*, an ever-increasing yield of new and newer technologies: the portability and pervasiveness of video – camcorders and global MTV – but also computer networks, cash machines, call waiting, fibre optics, laser discs, world news tonight or at any time of day, memory chips and microelectronics, computerised checkout counters, the promised arrival of High Definition TV and the

Steve Miller, *Untitled*, 1989, acrylic and silkscreen

suddenly ubiquitous Fax, computerised trading on the international exchange. The number of cues and available options, to borrow Cage's only partly metaphoric model, has multiplied at an almost exponential rate. With this, time seems not so much to *flow forward* as to *eddy* and *swirl*, proceeding by jumpcuts and montage; backward into the future and forward into the past.

The highwater mark of process art came and went with the 70s. Traversing a dispersal of the aesthetic (in a move somewhat misleadingly dubbed 'dematerialisation'), artistic practice re-emerged in the 80s in an expanding field of market operations, a realm of investment, speculation, sometimes even *entertainment* pure and simple. What appeared in theory as a clean break with the modernist past, emerges in practice as a tangle of diverse operations, a dizzying array that confounds the sense of boundary, a fray of finely wrought 'transactions'.

No sooner had opposing streams of Neo-Expressionism and Picture Theory art been identified – each with a more-or-less programmatic logic of semantic flows and valences peculiarly its own – than a third tributary came into view.[9] While artists of the first group entrenched themselves in the fixed-point of an individualism already in actuality exhausted, those of the second

have circled the grounds of art on a strategic nightwatch of appropriation, arrayed against the reifying imperatives of practices of representation. The introduction of this third 'body' of artists, however, running the gamut from Neo-Geo to commodity art, from post-appropriation simulation to a quasi-conceptual (and yet emotionally charged) environmentalism, has worked to destabilise the entire system.

The trajectory of art history, proceeding in the past by way of incremental alternations between classic and baroque, abstraction and representation – a series, in short, of bifurcations – stepped up the tempo of its oscillations to the point where, in the 80s, alternation gave way to a kind of cascade of 'post' and 'neo' stylistic variations. On the shoals of a collapsing capacity for critical distance, the course of art has churned and scattered, passing into an arbitrary flux of formal and conceptual variations, of 'hyper-simulated critical forms' and 'hybrid neutralisations'.[10]

The discourse of Post-Modernism sets up within the aesthetic a situation of extreme urgency and indeterminacy. Now more than ever, as they say on TV, we would seem to feel the force of Cage's call for performers in the aesthetic *cum* cultural arena

Strange Attractors: Signs of Chaos, 1989, The New Museum of Contemporary Art, New York, installation view

with 'a mind in one piece', 'alert to the situation, and responsible' (p39). Too sophisticated to invoke outmoded models (other than with the flourish of a high ironic style), profoundly sensitised to the complexities and uncertainties of current conditions in culture, artists, curators, and critics alike find their loyalties torn, divided between the paradigm of a critical practice past and the demands of an art world increasingly dominated by the market, with 'value' itself glorified and jeopardised by the new 'real estate' of art.

Chaotic Regimes

Economics borrows its notions of 'flow' from physics, and with that its mathematics, and from the beginning has been bound up with the development of complexity science. In a figurative aside from the main line of his argument in the article 'Strange Attractors', the mathematical physicist David Ruelle has offered a provocative picture of an economics informed by the science of chaos.11 Driven by an exponential rise in the value of the *single* variable 'technological development', the economy in Ruelle's model undergoes a phase transition (p47). Periodic cycles grow unstable and split into two. The economy enters a chaotic

regime. Wildly unpredictable locally – turbulent, discontinuous, *hysteretic* – it is globally 'stable' at the same time – a change in state that is also, irreversibly, a change in phase space shape.

Ruelle's 'metaphoric but . . . suggestive' model points to the idea that capitalism itself has changed shape, overflowing the boundaries between productive and reproductive or leisured space, overflowing the Euclidean geometries of a fixed system of social relations, subsuming the entirety of time to a logic of maximum circulation – in particular the almost instantaneous circulation of information (p47). 'Turbulent motion', writes Robert Shaw in *Strange Attractors, Chaotic Behaviour, and Information Flow*, is 'governed by information generated continuously out of the flow itself . . . preclud[ing] both predictability and reversibility.'[12] Following the line of argument developed by Eric Alliez and Michel Feher in their essay, 'The Luster of Capital', this transformation of capitalism stems in part from the social revolts of the 60s, and brings with it a renegotiation of the terms – the *narrative* terms – in which capitalism is conceived:

[A]n economic crisis always appears as an abnormal situation inevitably leading to an after-crisis: either a 'healthy' capitalism or the advent of socialism . . . However, the

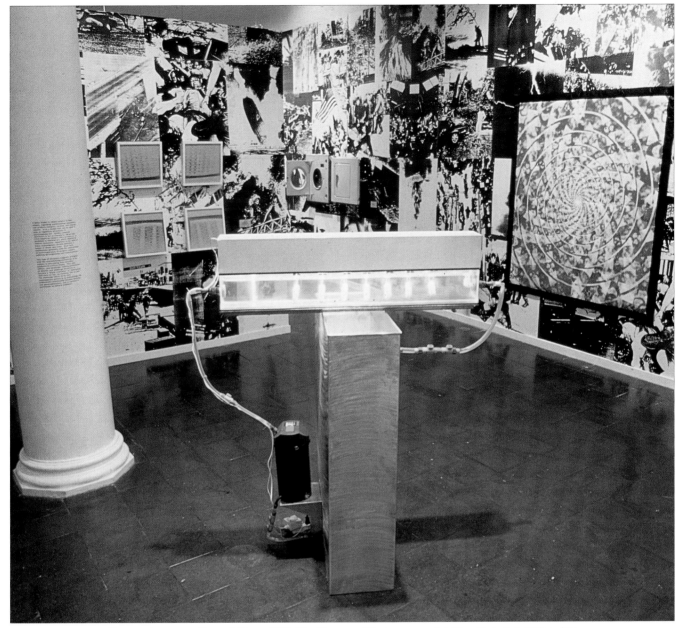

Strange Attractors: Signs of Chaos, 1989, The Museum of Contemporary Art, New York, installation view

current articulation of both a new regulatory mode of economic activity and of a new regime of capital accumulation . . . tends to turn this so-called 'crisis' into an ordinary, if not permanent state of affairs.[13]

What gathered and took shape in the guise of a crisis, promising to pass to a resolution, arrives instead as a *liquidation* of the very time-space of capitalist social relations. An apocalyptic model gives way to a new formation, setting the stage for a sea change in the climate of culture. Humans and machines become equivalent, 'assimilat[ed] . . . as cogwheels or relays in a vast machinic network for the productive circulation of information' (p316).

In *Chaos: Making a New Science*, James Gleick wrote of the effect of chaos science: 'One account of nature replaces another. Old problems are seen in a new light and other problems are recognised for the first time. Something takes place that resembles a whole industry retooling for a new production.'[14] Gleick's 'machinic' metaphor is striking, and its implications are at one and the same time exhilarating and frightening. In an essay contributed to the catalogue for the Goethe House exhibition, *Frontiers of Chaos*, Herbert Franke all but argued that the *cultural function* of the new science – of fractal graphics

and phase space maps – is tutorial in subtle, cybernetic, and far-reaching ways:

If we employ language as a means of communication, a linear medium arranged as a time-series, we automatically favour linear organising principles, eg causality or historical process. Visual languages allow us on the other hand to see those very important connections which manifest themselves as loop processes, interactions, communications networks, and so forth. Perhaps our inability to think in terms of networks is due in no small measure in our restriction to the descriptive system of verbal language.[15]

Our collective incapacity for thinking 'in terms of networks' is only equalled by the earnestness of our efforts to do so, as if the patterns traced by technology itself served as a kind of figural key to an emerging mode of social and economic exchange.[16] Witness, for example, our concerted conversion to an ideology of 'networking', with its own analogous operations of 'flows', 'loop processes', human cogs or relays, and vexed or digitised 'interactions'. Or again, consider the luminous but really rudimentary depictions of AT&T's global information network, with its imaginary circuits smoothly humming. We might, though,

Cady Noland, *Model with Entropy*, 1984, mixed media

also consider one last proposition from Alliez and Feher. In this emerging phase, they argue, capitalism 'leads to the dereliction of people and spaces that cannot be "plugged in" to the network' (p316). It is in these 'vacant spaces and bodies . . . only affected by the *flow of wasted time*' that the true chaos of the cultural moment would be seen to reside (p317, emphasis mine).

Losses and chaos of *all kinds* have recently called into question the ground on which aesthetic practice in the past relied. From the collapse of the autonomy of the aesthetic, artistic practice (and even the exhausted, now highly suspect, art *object*) re-emerged both humbled and exalted in its status as a prototype of 'interest' and 'investment'. In this dispersed aesthetic arena, of speculation and electronically charged transfers, of corporate sponsorship and governmental control, the issue for art seems to grow more urgent and indeterminate by the day. 'Distraction', Walter Benjamin wrote as early as 1936:

> and concentration form polar opposites which may be stated as follows: A man who concentrates before a work of art is absorbed by it . . . In contrast, the distracted mass absorbs the work of art . . . The public is an examiner, but an absent-minded one. (p240)

Benjamin argues that 'the tasks which face the human apparatus at the turning points of history cannot be solved by optical means, that is, by contemplation, alone'. (p240) With a newly-inflected emphasis on the complex processes of circulation and production, art becomes both measure and model of the shifts in apperception wrought by technology. The exponential increase in the value of the cultural variable, technological development, gives to Benjamin's 'absent-mindedness' an unexpected spin:

> Dear Reader:
> When you need information to help you make important decisions in your life, where do you find it? How do you even know what's out there? And, how can you get your hands on it, fast?[17]

If the new science offers a set of tools (specifically, seeing eye tools) for transiting to an unimagined form of collective subjective experience, the question concerning technology becomes one of *who is absorbing whom*, and art becomes a *matter* of *distracting* our collective state of distraction. Artistic practice is issued a strange new challenge, a kind of awful but domestic imperative. While there is no ordinary score, a determinate array of strategies makes itself available as a figure for the digressions and deflections of cultural history begins to take shape. At once elegant and unpredictable – elegiac perhaps, unnerving – art and culture appear here as a 'venture' that does not progress, but instead cycles endlessly on an erratic orbit, shot through with the energy of saturated video graphics, exerting a well-nigh disconcerting and mesmeric appeal.

Notes

1 Walter Benjamin, 'The Work of Art in the Age of Mechanical Reproduction', in Hannah Arendt, ed, *Iluminations: Walter Benjamin*, 1969, Schocken Books, New York, pp217-252, p240.

2 Peitgen and Richter, *Frontiers of Chaos: Computer Graphics Face Complex Dynamics*, exhibition catalogue, 1985, Forschungsgruppe Konplexe Dynamik, Universitat Bremen, pp61-100, pp72, 66.

3 *ibid*, p66.

4 Thomas Kuhn, 'The Structure of Scientific Revolutions', *International Encyclopaedia of Unified Science*, 1962, 1970, Otto Neurath, Ed-in-Chief, vol 2, no 2, The University of Chicago Press.

5 David Campbell et al, 'Experimental Mathematics: The Role of Computation in Nonlinear Science', *Communications of the ACM* 28, no 4, April 1985, pp374-384, p377.

6 Michel Foucault, 'Nietzsche, Genealogy, History', in Paul Rabinow, ed, *Foucault: A Reader*, 1984, Pantheon, New York, pp76-100, p88.

7 Poincare argued, on mathematical grounds, that while Newton's laws of planetary motion held good for systems of just *two* bodies, the introduction of a *third* has the potential of destabilising the system and rendering orbits erratic, unpredictable. See John Briggs and F David Peat, *Turbulent Mirror: An Illustrated Guide to Chaos Theory and the Science of Wholeness*, 1989, Harper & Row, New York, p29.

8 John Cage, 'Indeterminacy', the second of three lectures on 'Composition', in *Silence: Lectures and Writings by John Cage*, 1961, Weslyn University Press, Middletown, pp35-40.

9 On this, see Tricia Collins and Richard Milazzo, *Hyperframes: A Post-Appropriation Discourse*, 1989, vol 1, Editions Antoine Candau, Paris, pp13-14.

10 Tricia Collins and Richard Milazzo, *Hybrid Neutral: Modes of Abstraction and the Social*, exhibition catalogue, 1988, Independent Curators, Inc, New York, p8.

11 David Ruelle, 'Strange Attractors', in Predrag Cvitanovic, ed, *Universality in Chaos*, 1984, Adam Hilger Ltd, Bristol, pp37-48.

12 Robert Shaw, 'Strange Attractors, Chaotic Behaviour, and Information Flow', 1981, *Zeitschrift fur Naturforsch*, 36a pp80-112, p106.

13 Eric Alliez and Michel Feher, 'The Luster of Capital', *Zone* 1/2 (nd), pp314-22, p315.

14 James Gleick, *Chaos: Making A New Science*, Viking Penguin, New York, p39.

15 Herbert Franke, 'Refractions of Science into Art', in *Frontiers of Chaos*, pp45-52, p47.

16 On this, see Fredric Jameson, 'Post-Modernism or The Cultural Logic of Late Capitalism', *New Left Review*, No 146, July-August 1984, pp 53-92, where aesthetic production is seen to imitate the dominant mode of production at a given historical moment, and technology serves as a shorthand for the information networks of multinational capitalism. See also Hal Foster, 'Signs Taken for Wonders', *Art in America*, Vol 74, No 6, June 1986, pp80-139, especially note #14.

17 'America Needs Information', Promotional mailing for AT&T Information on CallTM, 1989, p2.

Jill Levine, *Like Minds*, 1988, oil paint on modelling compounds and plastics

Object Relations (2nd panel), 1989, mixed media, 185.5x124.5x4cm

VICTOR BURGIN
A NOTE ON MINNESOTA ABSTRACT

Minnesota Abstract, 1989, linotronic print, 7.7x23.3cm

In the summer of 1989, I was invited to make a work in the 'Twin Cities' of Minneapolis/St Paul. This was not the first time I had received such an invitation: I have also made site-specific works in response to commissions in Berlin, Lyon, Grenoble . . . and more recently, Boston and Adelaide. I have always tried to make a visual representation of what I might call an 'apprehension' of the place

to which I've been invited. There is no word for it today, but if I were in the 18th century I might have spoken of my attempt to give image to the 'genius of the place'. Over the years, psychoanalytic theory has become the critical tool I use most often in trying to understand the mechanisms at work in visual representations – from classical painting to modern advertising. Freud's original discovery – the foundation stone of psychoanalysis – was that thoughts we find painful, or otherwise cause us anxiety, may be repressed and thereby made unconscious. The unconscious thought however is likely to return to us in a disguised form. For example, the repressed idea, or memory, might return as a seemingly inexplicable physical symptom, or as an apparently nonsensical dream, or in the form of a slip of the tongue or some other error, or as a joke. I'm becoming increasingly interested in the idea that we encounter the 'return of the repressed' not only at the level of the individual, in the speech and dreams of that individual, but also at the level of the nation, in its various cultural products. The histories of many nations contain painful and discreditable facts. Great Britain, at the end of the 19th-century, at the height of its power and prestige, probably preferred not to remember the extent to which its great wealth had been derived from the slave trade. A painful fact of American history is that the United States is founded on an act of expropriation, in which the indigenous peoples of the North-

American continent were systematically deprived of their lands. This fact had been brought to my mind earlier in the summer when I spent some time in Vancouver, and visited a part of the city which had been returned to native Americans as the result of a land-rights case. It was perhaps inevitable that it should be on my mind when I visited Minneapolis. Here, I was presented with an environment in which the repressed images and names of native Americans constantly return: on labels of products on supermarket shelves, in corporate logos, on automobiles . . . and so on.

Shortly after I arrived in Minneapolis, the Sunday July 23 edition of the local *Star Tribune* newspaper carried a story headed, 'Historian finds names of Minnesota's forgotten Indians'. Although it was a local story, concerning the Twin Cities, the story came from an outside agency, the Associated Press. It was based on information supplied by Virginia Rogers, working for the Minnesota Historical Society in St Paul. The part of the story which caught my attention read:

The US government created the 837,120 acre White Earth Reservation in 1867, intending that all Chippewa Indians be relocated there. As enticement, the government offered 40 acres of land for every ten acres cultivated . . . for nearly 20 years the Chippewa who relocated to White Earth fulfilled government expectations, farming quite success-

fully. In 1885, however, white settlers on adjoining Red River Valley lands adopted a resolution demanding that the reservation be opened to white settlers ... For the next two years, Episcopalian Bishop Henry Whipple lobbied Congress and the administration on behalf of White Earth Indians. All of Whipple's efforts were in vain: by 1982, just 1,952 acres remained in trust.

The name 'White Earth' reminded me of the name 'Little Earth' – a Federal-sponsored 'HUD' housing development in the Twin Cities occupied mainly by native Americans. Since the project was built, the care invested in it by the people who live there, together with a changed market situation, has turned what was originally assumed to be a strictly non-commercial housing project into an attractive, potentially profitable, 'investment opportunity'. Today, official mismanagement of Little Earth has brought it to the point where the project is in danger of being taken from the people who now live there, and sold to private interest – and this in spite of the scandal over alleged massive frauds perpetrated by HUD officers during the Reagan administration. The *Star Tribune* story about White Earth concludes: 'White Earth prospered until people outside the reservation realised that the Indians had rich resources in trees and farm land ... Then they legislated the reservation nearly out of existence.' It seemed that history was threatening to repeat itself: what had happened then to White Earth could happen now to Little Earth.

The famous 'first rule' of psychoanalysis is to say what first comes to mind. I try to apply that rule when I work. Structurally, the work represents a *condensation*. Freud observed, 'The dream is laconic by comparison with the interpretation'. A dream image, or a fragment of the analysand's speech, may serve as a cross-roads where several paths of thought intersect. The ideas are packed into the relatively small space of the image. In Freud's terms, such images are formed by a process of 'condensation'. This is the way I plan my images – as condensations. In this work, the image in the central panel is built of elements derived from logo-types which make 'Indian' references: *Mutual of Omaha; Detroit Bank and Trust; Continental Airlines*. The following buildings are cited, in St Paul: *Minnesota World Trade Centre Cathedral of St Paul; Minnesota State Capitol*. In Minneapolis: *IDS Center Tower; Piper Jaffray Tower; Normandy Inn Best Western*. For me, new to the Twin Cities, these are the buildings which seemed to give a distinct signature to the skylines. I based the shapes I used on sketches and Polaroid photographs taken in the street. These shapes went through several stages and evolved into forms which made me think of the work of Stuart Davis. I was living near the Walker Art Centre. On one of my visits to the museum I checked to see if they had a Stuart Davis painting in the collection. Sure enough, they did. The title – *Colonial Cubism* – seemed too much of a gift to ignore: Western-European colonialism had always advanced through the building of forts, followed by cities; literally cementing itself into place. Davis' painting is unusual in that it does not contain the elements of writing he usually incorporates into his work. I therefore took it on myself to draw the words in the title of Davis' painting, 'forging' them in his own characteristic style. The colours? 'Legally' expressed market relations were the alibi which turned 'expropriation' of native American lands into the more respectable 'purchase'. So, for example, in 1803, through the 'Lousiana Purchase', the United States bought almost 900,000 square miles of new land from France. A few square miles of this parcel, lying west of the Mississippi River near its confluence with the 'St Peters' (later, 'Minnesota') River, later became part of the Twin Cities. For this reason the colours of my panels quote the red, white and blue of 'Old Glory' in a format which more directly evokes the 'Bleu, blanc, rouge' of the French *tricolor* – much in evidence in the Bicentennial Year of the Declaration of the Rights of Man.

I use computers to make my work. Does this make me a 'computer artist'? No more than it makes someone who uses a pencil a 'pencil artist'; no more than a painter is a 'paint-brush artist'. To make this work I used an Apple *Scanner* digitiser to feed my drawings, photographs and other image-fragments into my computer. You can think of the scanner as the input end of a zerox machine; on the output end, instead of hard copy, you get an 'image-file' consisting of binary digits. Next in the production-line from the scanner was an Apple *Macintosh 11* computer, with a colour monitor. This machine allows me to edit and manipulate the scanned image in a variety of ways, and also to draw images directly to the screen – depending on the particular software, or 'programme', I use. I also scanned my own pencil drawings into the computer in order to be able to further modify them while retaining the original. Today – in so-called 'desk-top publishing' – the Macintosh computer has virtually taken over from traditional methods of page lay-out for publications, from simple brochures all the way through to substantial books. The 'Mac' is also increasingly coming to replace traditional dark-room techniques for the manipulation of photographs. The photograph is now scanned into the computer, where such operations as contrast and colour control, burning and dodging, cropping, and so on, are performed on screen. There's no need to stand in the dark, up to your armpits in toxic chemicals. For proofing my drawings I used an Apple *Laserwriter II NT*. You can think of the Laserwriter as the output end of a photocopying machine, with a computer bolted onto it to receive and translate the information coming from the *Mac 11*. There are basically three sorts of printer available: *Dot-matrix printers*, such as the Apple *ImageWriter 11*, produce 'screen resolution' images – 72 lines of dots per inch ('dpi') – acceptable for text but not satisfactory for graphics; *Laser printers*, like the Apple *Laser-Writer 11 NT*, produce 300 dpi – adequate for low-budget 'cheap and cheerful' printing jobs, and for proofing graphics; *High resolution printers*, for example the *Linotronic*, can produce up to 2450 dpi (6,002,500 – dots per square inch). Linotronic machines are extremely expensive, but Linotronic output is available at moderate cost from service bureaus. The final colour separations that I sent to my silk-screen printer in New York, together with colour sketches and other instructions, were Linotronic prints.

I called the finished work *Minnesota Abstract* as it draws on elements abstracted from Minnesota history, and includes a reference to the Stuart Davis 'abstract' in the Walker Art Center. As I began by saying, the work was an attempt to sum up, 'condense' in an image, some of the perceptions, thoughts and feelings which came to me in the Twin Cities. Work didn't stop there. The historical parallel to be drawn between 'White Earth' and 'Little Earth' seemed worth pointing out in public. I took the central graphic element in *Minnesota Abstract* and combined it with a text – set in parallel columns – based on the *Star Tribune* story and what I had learned about the HUD housing project. Through the agency of a friend in Minneapolis I asked a native-American organisation to check my text, and changed it in line with their suggestions; they gave their approval to the finished design. This piece was made for the street rather than for the gallery – designed in black and white, and in 'US Letter' format, so it could be cheaply reproduced on a photocopy machine. I asked the organisation which had invited me to Minneapolis to help me print and distribute the 'street work', as they had expressed an interest in 'public art'. They declined, worried about embroiling themselves in a controversy that might affect their funding (this was the summer of the Jesse Helms/Mapplethorpe furore). The Minneapolis critical monthly journal

Artpaper had, independently, already offered me their back-cover as a site for the 'street' piece, and I had designed another version to fit their 'tabloid' format – it appeared in the October issue; *Artpaper* ran off extra copies of the page for posting in the streets. All of this illustrates what is, for me, one of the great advantages in using a computer – a lengthy process had gone into the making of *Minnesota Abstract,* but once the elements had been stored in computer memory I was able to quickly restructure them in response to changing circumstances.

I've explained something of how I came to make this work. Is my explanation of the decision-making process the 'meaning' of the picture? No – I've had this confirmed many times in the past when other people have found meanings in my work I was not myself conscious of. Moreover, I've said nothing about the 'affect' of line, form and colour. (I tend to agree with Wittgenstein – 'whereof we cannot speak, thereof remain silent'.) Unlike my essays and talks, and my occasional works for the street, my works for the gallery are not constructed in the form of an explanation. I distinguish 'gallery work' from 'public work' primarily by the form of address it involves – a relatively 'open' structure which allows more freedom of association to the viewer (although what one is asked to associate *about* is strongly indicated). The word 'public' conceals a complexity of heterogeneous audiences, with various reading protocols and competences, situated within different institutional contexts, which in turn imply their own particular frameworks of 'legitimate expectations', and so on. In navigating such complexity I am guided by the old adage: 'form follows function'.

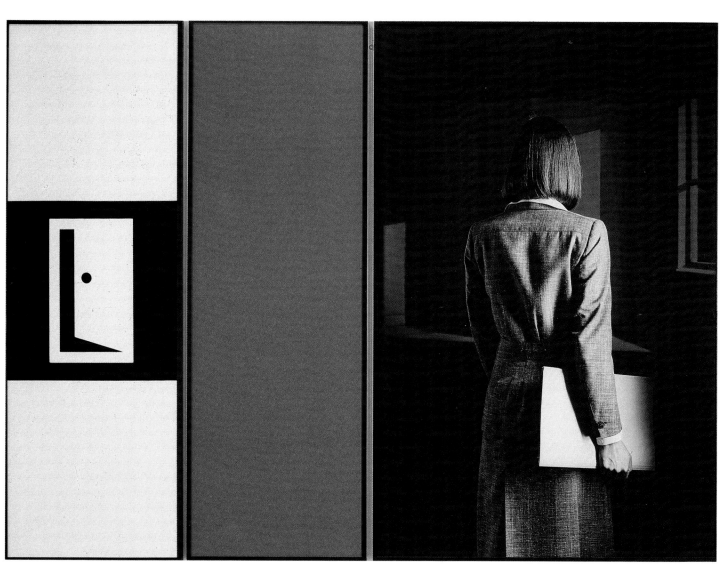

Office at Night, 1986, mixed media, 183x244cm

———————— * ————————

I WAS
SICK FROM
ACTING NORMAL.
I WATCHED
REPLAYS OF
THE WAR.
WHEN NOTHING
HAPPENED I
CLOSED A ZONE
WHERE I
EXERT CONTROL.
I FORMED A
GOVERNMENT THAT
IS AS WELCOME
AS SEX.
I AM GOOD
TO PEOPLE
UNTIL THEY DO
SOMETHING STUPID.
I STOP THE
HABITUAL MISTAKES
THAT MAKE FATE.
I GIVE PEOPLE
TIME SO THEY
FEEL THEIR LIVES
MOVING OVER
THEIR SKINS.
I WANT A
LARGER ARENA.
I TEASE WITH
THE POSSIBILITY
OF MY
ABSENCE.

Laments, 1989-90, drawing for one of the texts inscribed on 13 stone sarcophagi and presented on LED signboards, DIA Art Foundation installation

66

JENNY HOLZER
LAMENTATIONS

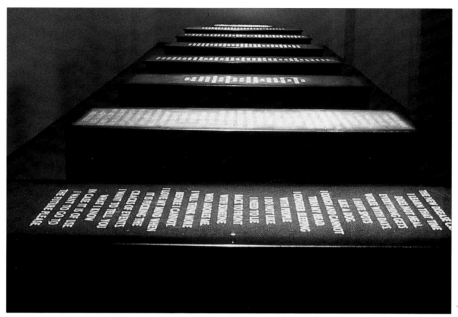

Laments, 1989-90, stone sarcophagi, installation detail, DIA Art Foundation, New York

'I tease with the possibility of my absence.'
'I see space and it looks like nothing and I want it around me.'
'I want to tell you what I know in case it is of use.
I want to go to the future please.'

The selection of New York artist Jenny Holzer to represent the United States at the Venice Biennale in 1990 – the first woman artist ever to do so – is significant in reflecting the current thinking of critics and curators active in determining the direction of new art, dominated as it is by the use of written texts and mass-media techniques, and aiming to communicate to an audience outside the confines of the commercial gallery space, confronting themes that go beyond the self-referential to explore socio-political issues relevant to the new decade of the 90s.

Having gained international recognition (including the recent exhibition at the Guggenheim) for projects which have ranged from the *Truisms* of the 70s – anonymous poster texts pasted onto the walls of SoHo – to the *Survival Series* of the 80s – aphorisms transmitted as electronic messages by means of light-emitting diode machines and displayed in public contexts, juxtaposed to advertising billboards and even displayed on Underground TV monitors – the recent installation commissioned by the DIA Art Foundation, the *Laments*, signifies both a consolidation and expansion in Holzer's thinking, combining stone and electronic media in the context of an entire warehouse space in West 22nd Street, New York.

While the degree of force and critique communicated by Holzer's public messages lay in the fact that the artist was operating within a familiar commercial, non-art context, to unexpectedly question and undermine the anonymous voice of authority and persuasion, a new force is achieved in the *Laments* installation, which juxtaposes the transience of the electronic medium with the solidity and permanence of 13 'voices of the dead', inscribed on stone sarcophagi and installed in the blacked-out, enclosed space of the DIA Foundation. This combination of the transient and intransient marks a continuation of ideas initially explored by Holzer in her 1986 installation at the Barbara Gladstone Gallery, New York. Titled *Under a Rock*, the installation comprised granite benches inscribed with messages and confronting an electronic signboard, transmitting the same text yet fragmenting it into a succession of perpetual instants that communicated a sense of dislocation and accelerated time.

In *Laments*, both media communicate Holzer's new poem-texts, programmed in changing patterns onto 13 electronic signboards and transmitted vertically on columns, working both visually and linguistically as dislocated words of red, green and yellow light, and simultaneously inscribed in stone as continuous, haunting texts, confronting timeless themes such as mortality and the future, and focusing on contemporary issues, including that of AIDS.

Influenced by the writings of Samuel Beckett and representing a continuity with the concept of language-based art established by artists such as Joseph Kosuth, Holzer's art nevertheless

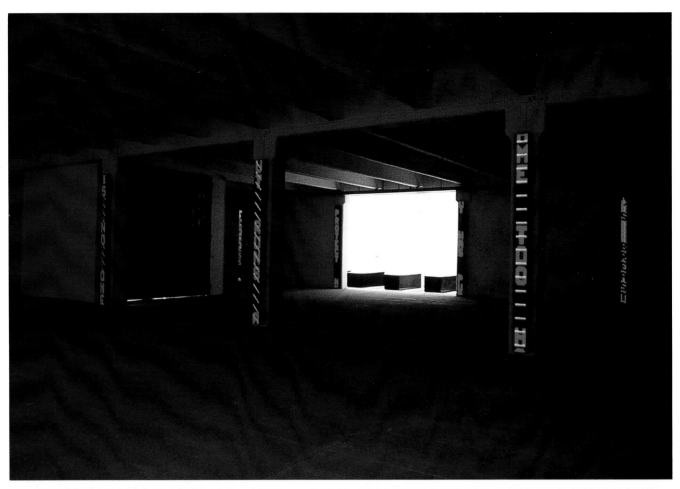

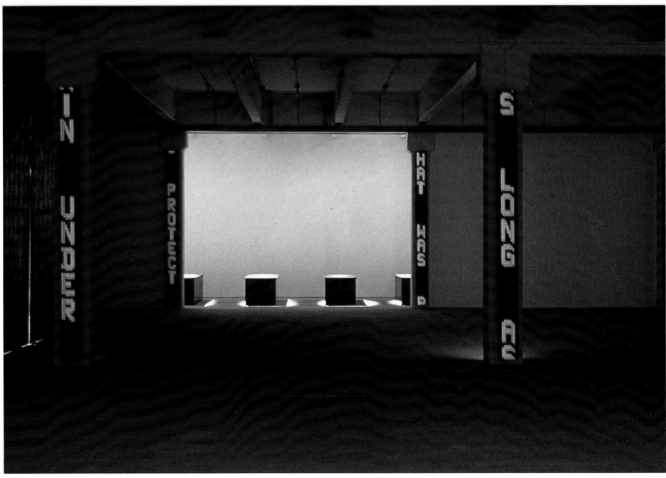

Above and Below: Laments, 1989-90, installation views

THOMAS LAWSON
GOING PUBLIC

Thomas Lawson, *A Portrait of New York* (detail), 1989, billboard/mural, 2.4x518.2m, Manhattan Municipal Building, New York

As I sit down to write this I have just completed a huge public commission for a temporary installation on the outside of one of the main centres of local government in New York City. Stretching for about a third of a mile, this billboard/mural will encircle the Manhattan Municipal Building for about five years during a major renovation project. Painted in a declarative style using

a limited, but very bright, range of colours (derived from the orange and blue of New York's flag), the painting inserts itself forcefully within the daily life of that part of the city that houses the enforcers of government – this is where you must come for a licence to marry, build, do business; the Police headquarters are in the area, as are the offices of the FBI, the Immigration Services, the Customs; so are those other branches of the law, the courthouses and gaol. Within this framework my goal was to open the possibility that ordinary citizens might want to reconsider aspects of the official representation of the city proffered by the authorities. The imagery I worked with is all developed from New York's civic statuary, an archive of power frozen in a past time that keeps women safely allegorical and minorities all but invisible. A panoply of men in period and contemporary costumes, arms flung about in the gestures of impassioned rhetoric, is caught between the close-up faces of staring children and laughing women. The men, mostly New York politicians repeat themselves absurdly as they adopt the official postures of power. The women and children are simply repeated, to emphasise their absence elsewhere.

I'm hardly the first artist to become interested in intervening in public space, nor have I been alone in moving away from the restricted confines of the art market in recent years. Indeed quite a few of my generation, artists who began with an investigation

of the structure of meanings articulated within the privileged space of the art gallery, have been shifting attention to the actual spaces of the City. We have been steadily moving from a private experience shared by a few, and equally ignored by the many, to a larger, more inclusive, and definitely social interaction. We have all done billboards, bus and subway posters, and other forms of transitory public art. Since it is unlikely that any of us seeks fresh air and sunshine in the name of art, it seems safe to say that what is going on is a widespread effort to recast art production as an activity of social meaning. As Declan MacGonagle, putting together the first Tyne International, has said, we are facing 'A New Necessity.'

The old necessity was precisely to return attention to a market structure that had been willed into invisibility. In the early days of the Neo-Expressionist boom, the idea of this work as subversive was pretty tenuous; by the time Jeff Koons was in full swing it had become risible. But over a decade ago, in that now unimaginable period before Reagan, Thatcher, or Kohl, the last-gasp *avant-gardist* work of Conceptual and Post-Minimal artists had succeeded in isolating art from all but its own discourses. A concentrated self-examination had exposed the ideological underpinnings of a certain subculture alright, but in the process left most people disinclined to care. To many of us then it seemed that our elders had brought art very close to being a meaningless

activity in the least exalted way, and that it was imperative to try to reconnect to the larger world. Two congruent strategies emerged in this attempt, both necessarily rooted in what we understood to be current dogma.

The first was a calculated return to the use of images – 'recognisable imagery became the favourite term of the professional packagers. This imagery was recognisable because it was taken – or 'appropriated' to use another then fashionable word – from sources in the mass media, with the intention of raising questions of meaning within the broad scope of cultural representation. Simply put the question posed was: if we know what these images are, if we in fact recognise them, do we then know what they mean? Since the answer is almost certainly negative, we are suddenly face to face with a kind of crisis concerning the apparatus we use to construct our daily lives. Asking this question in relation to both art and mass media proved to be quite liberating, opening up new territories for exploration, and re-opening some that had been apparently closed. Of the latter, of course, the most prominent was the issue of painting, that old bourgeois practice so thoroughly discredited in the 70s. Indeed the re-emergence of painting was, at the time, the most energis-

tionist work was concerned with the whole idea of the spectacle of consumption that was bound to face that spectacle head on.

What I am saying, then, is that the desire to re-insert art within a meaningful social discourse in the US of the late 70s, inevitably meant that the new work had to concern itself with a context – the art market – that artists tend to view with ambivalence. Almost from the beginning this idea of a reactivation of the marketplace as a context in contention became a disputed one. It was very much an art concept, not a thoroughly articulated strategy, and so there was no real understanding of how quickly the flow of money would replace the flow of ideas. Marketing overwhelmed discourse as the art world moved into the hyperreal world of product promotion and star creation. Money talks, but it rarely allows anyone a word in edgewise, and soon the only topic discernible in the work on display in the galleries and in the magazines was money itself.

Sensing this incipient problem many artists, notably many women artists, rejected this model of activity, preferring a more directly political mode of operation. Jenny Holzer, for instance, sought out a different audience by carrying out a campaign of small-scale billposting throughout Lower Manhattan at around

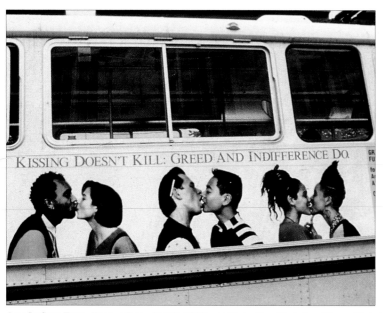

L to R: Gran Fury, *Kissing Doesn't Kill*, 1989, panels on New York bus; Group Material, *Education & Democracy*, *Democracy* (Part 1), 1988, DIA Art Foundation

ing of options, containing the most possibility of creative contradiction. The hand-made work foregrounded the problem of subjectivity raised by all appropriationist work, and did so while reasserting the importance of sensuous pleasure. It thus saved appropriation art from being merely a bureaucratic continuation of fundamentalist Conceptualism by other means. It must also be said that some of the pleasure of the new painting derived from the knowledge that its very existence infuriated so many of our mentors and teachers of the previous generation.

The re-emergence of painting as a legitimate working method also facilitated the second strategy of the moment, the decision to place art once again within the arena of the market. In retrospect this always risky strategy has proved a disaster, leading down a path of increasingly diminishing possibilities for continuing to make interesting art. At the time, however, a deliberate return to the marketplace seemed an obvious way to begin wooing the attention of a wider public pretty much conditioned by a rampant consumerism to consider only things offered for sale. We thought we could do this and engage in some clever ironies at the same time. Even now it is hard to say there was any alternative, since it was precisely because appropria-

the same time that David Salle was insinuating his painted manifestoes into SoHo galleries. Of a size that spoke of an economy that was both necessary and right, her handbills listed, in alphabetical order, a cacophony of statements that, taken together, defied all logic. The confidence of these *Truisms*, statements of personal belief and public knowledge, is shattered in the confusion of their ridiculous contradictions. Coming across these anonymous warnings on a broken-down wall in the East Village, or, later, flashing on an electronic signboard at Caesar's Palace in Las Vegas, a shopping mall in Philadelphia, a sports stadium in San Francisco, one recognises a staginess, even a kind of hysteria. The voice of authority is made as urgently unbelievable as that of a crazy person. Holzer's dire stream of language, in its electronic proliferation throughout the public spaces of modern life, denies the possibility of a personal voice by seeming to insist upon it.

Taking a somewhat different tack Barbara Kruger attacked the problem of self-representation by developing a very distinct persona through the idiosyncratic voice of her writing. Advancing at high speed, this voice pushes hyperbole to the limit as it displays a position in relation to the fantastical world of televi-

sion and the movies. It is a voice by turns sympathetic, amused, outraged. Descriptive aphorisms – the incessant shifting of attention from subject to object and back, the sense of detail as an index of the absurd, the referencing of present insults to a history of their return appearances in popular culture since the 40s – provide the structure upon which Kruger builds everything, from her column in *Artforum* to her large photo/texts. These latter, presented in galleries and as billboards on the street, work through the disjunctive placement of mostly sentimental images recalling a particular vision of domesticity with a typographic riot aimed at shattering the complacency of such images which are of women, but not for women.

One of the side effects of a triumphal Reaganism has quite clearly been the return of a kind of State art, an art that glorifies the *status quo*. For some time conservative forces have been fashioning a theory of the end of history, a blueprint for cultural totalitarianism that also gives believers permission to ignore the cries for betterment from those shut off from Reaganite prosperity. This theory obviously dovetails nicely with the passive radicalism of Baudrillard, providing the purveyors of advanced art with a handy way to stay up to the minute and yet upset

becomes nothing more than the ineffectual bleating of an élite whose job it is to show the human face of entrenched power. In the wake of this prolonged discovery, politically motivated artists have begun aggressively seeking more combatatively discursive methods of working.

In many ways the richest of these experiments have been carried out by Group Material, a small, and changing collective that organises large, bewilderingly inclusive exhibits in art spaces and public spaces. The point has been to open up discussion of contemporary cultural life in the US, on as many levels as possible. Many diverse contributions are solicited, from artists, well-known and not, politically correct and not; from non-artists, people in the work force; from school children. The material collected is then displayed in highly self-conscious formats: heavily designed, one might even say didactically designed exhibits; newspaper inserts, poster campaigns on public transport. The framework of the show then gives what is shown its focus. Thus a project in which 100 people provided posters for one line of the New York subway system seemed to get around issues of violence, domestic and political. Another project at the Whitney Museum of American Art, a project that

L to R: Group Material, *Politics & Election*, *Democracy* (Part 2), 1988, DIA Art Foundation; Jenny Holzer, *Inflammatory Essay*, 1978/79, Lower Manhattan

nobody. Scepticism of progress has been turned into a convenient denial of its necessity. Throughout the decade, opposition, in politics as much as in art, was rendered marginal, and from that enforced marginality began to gain strength. By the latter part of the 80s, a new sense of urgency had re-ignited the desire for an engaged art.

The return of an alternative to market-driven art is hardly news in itself, after all it provides convenient cover for those who fail to make a killing as much as an honourable position for crusaders of the avant-garde spirit. What is more remarkable during this period has been the growing desire to place these alternatives in public space with the intention of stimulating public discourse on the nature of the society we have and want. After much talk, and little to show for it, political artists in the United States have been faced with a realisation. Simply making pictures of outrages and abuses, even using more so-called advanced techniques than painting, is not a particularly effective tool for political change. Indeed, given the co-optive power of mainstream culture, such pictures function in opposition to the artist's intentions by masking a social reality with the veneer of tender-hearted concern. Political art, relegated to a stylistic option,

foregrounded American consumer objects against a wall of popular art and artworks from the Lower Manhattan art ghettos, addressed the oscillation between conformity and diversity that fuels cultural debate in this country. In their most ambitious work to date Group Material took over one of the galleries of the DIA Foundation for several months in 1988 in order to open a debate on the issue of representation in democracy. Four separate exhibits were organised, *Education and Democracy*, *Politics and Election* (to coincide with the Presidential and Congressional elections), *Cultural Participation*, and *AIDS and Democracy: A Case Study*. All four exhibits provided diverse information in a designed, but welcoming environment with plenty of seats, tables, printed and videotaped information. There was art in abundance, from figures as unalike as Leon Golub and Peter Halley. There was also plenty of non-art and bad art. During each segment of the project, various meetings and discussions were held, and by the end a publication planned. The series was successful in opening up possibilities; differences and inadequacies were displayed alongside unexpected moments of strength. The entire debate was problematised, with no practice or artist put forward as having a lock on truth, or even effectiveness.

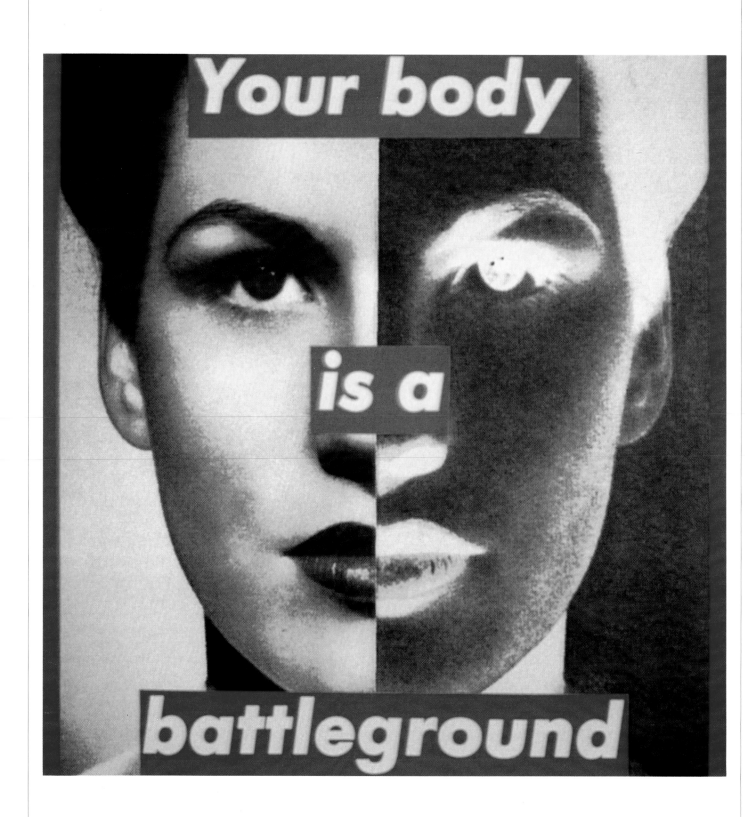

Barbara Kruger, *Untitled* (Your body is a battleground), 1989, photographic silkscreen/vinyl, 284.5x284.5cm

Group Material's contribution, then, was to provide a context in which the context of art could be aired and discussed, an open-ended context free of the imposed certainties of quality or the politically correct. They provide a blueprint for what we must hope for in art in the coming years as the unfolding crisis in the East inevitably creates a response in the West.

Not that a cultural crisis has not already gripped the West. We know too well the tightening grip of the forces of reaction, the increasingly homogeneous production approved for mass consumption, the hot breath of official and unofficial censors seeking scandal with anxious prurience. Western culture is a battle zone, a fact only too clear to those working on the frontline of AIDS awareness. To date some of the most effective attempts to bring art production back into the mainstream of public policy discussion as a potent element in the creation of cultural self-representation have been the zap-attacks of ACT/UP and the poster campaigns of Gran Fury, both collectives that are as much, if not more concerned with AIDS activism as with art. But not all the activity I'm thinking about has been so pointed, or even so anonymously collective. Of equal importance are Krzystof Wodizcko's exemplary interventions, nocturnal attacks on the very bastions of entrenched power, or the poetic disjunctions of the billboard works of Jessica Diamond or Felix Gonzalez-Torres. It is not the case that art must now become a species of agit-prop, or at least not that alone. It is the case, however, that artists who continue to hold themselves clear of contamination from the world at large are condemning themselves to an increasingly unforgivable irrelevance. There can be no strictures on how to connect, only that we had better. This is the new necessity.

Kryzstof Wodiczko, *Glasnost in USA*, 1989

F-451: Macbeth Act I, 1988-89, ashes, matt varnish on rag book pages on linen, 96.5x101.6cm

ANDREW RENTON
TIM ROLLINS + KOS
An Open Book

Winterreise – Die Nebensonnen, 1988-89, acrylic and mica on music sheets on linen over wood panel, 22.9x30.5cm

educate – *vt give intellectual and moral training to; provide schooling for; train . . . (fL* educare *. . .)*
educare – *to lead out.*

When it is first seen, the book is always closed. To read necessitates engagement of a particular kind. With every reading the book is remade, rewritten. The book is unchangeable, yet always changed.

We cannot perceive the book all at once. The absorption takes place over time. Tim Rollins + KOS expose the book towards simultaneity. Their's is simply a reading, like other readings, only their own. The journey towards the creation of a finished piece at the Art + Knowledge Workshop is a long one. Understanding is hidden deep beneath the surface. To resee the surface takes time.

The *Amerika* series draws from Kafka's novel of the same name. Common ground here is the experience of alienation, otherness and annexation. The starting point of being already displaced creates, in turn, the desire to stabilise, to make a mark, and have it seen as one's own. The transformation is towards something entirely unforeseen, because it reveals the intellect unburdened, something deeper, and less self-conscious. *Amerika* speaks again. The Kids of America speak. There is synergy.

The *Amerika* series is a complex world of dreams and fantasy laid bare. The impossible golden horns – the starting-point of the whole KOS enterprise – have given way to restraint and discipline. In *Amerika I* the imagination runs riot; it takes another 12 major paintings, and hundreds of sundry drawings to work the

system out, and work it out of the system. The golden horns could accommodate and comment upon anything: the AIDS virus, drugs, violence, atomic war, the Declaration of Independence.

Text becomes texture and context at once. For Rollins and the Kids the painting is a critical act, an interpretation. Nothing comes from nothing: all new art is the deliberate amplification and suppression of the pre-existent. The critical act is a response at the level of the self rather than the text. Understanding a text is to give oneself to that text. A new text is made, or rather the old text becomes one's own.

But collaboration is a dangerous business. The necessity of giving of oneself can, if mishandled, result in the giving up of oneself. Tim Rollins is the name at the head of the class, but the KOS are, by definition, a transitional grouping. They are not constrained by the working body, but rather, this is their outlet, and starting point, for emotional expansion. The art is one of translation and excavation. It is all there, always, within all of us, but it needs bringing out. Slowly.

Over the past year or so, the making into image has become simpler, more singular. Execution is a small part of the process. The notion to be represented evolves over a period of months. The works produced within this collaborative arrangement are the lingering residue of something more significant. Tim Rollins

Black Beauty II, 1988-89, acrylic, mica on book pages on linen, 182.9x177.8cm

+ KOS seem now to be engaged in a ritual of subtraction, as if to clarify images made unclear by complication. There is self-expression at the very core of the enterprise, but the presented work is like an expressionist *trace* – the effect without the accompanying obfuscatory detritus. *Black Beauty* moves away from an applied mimesis to one more universalised – the text itself is copiously illustrated – and resorts to the simple vertical black stripes. Somehow Rollins + KOS can combine symbolism and Minimalism at once. The stripes are even and uncomplicated – a pure geometry. But they are also the consolidation of months of searching for images which could convey restraining gestures for the story in the book. The final 'image' is, of course, of prison bars, still mediated by the paint as its own subject. Momentarily, there is a common aspect shared by Peter Halley's cells. Here, however, what you see is most definitely what you get: everything is brought to the surface.

The *Winterreise* project is a still more radical departure. The score of Schubert's song cycle becomes a text like all the others, although it is still one more stage removed. The score is presented visually. To function as a score, it must be read and then performed. The recreation of Schubert's music is far down the semiotic chain. Yet this is not a problem for the representation, or one might say, the de-representation. For Rollins + KOS can only fade away the score over the huge progression, some 60 feet in length, by means of snow-white paint. This gradual effacement is a mimetic abstraction of the journey experienced by the solitary traveller thrust out into the snows, moving further and further away from familiarity. A self-exclusion by choice, or by default. A *diminuendo* of sorts, paradoxically rendered visible by rendering invisible.

Winterreise, remade by Rollins + KOS, assumes an unusual positioning in relation to the hieroglyphics of 'high' culture. The score is without question unreadable, in itself, to most of the Kids, but their project can accommodate the loan. They borrow, just as Schubert himself borrowed from Müller, to make *Winterreise* a reflection of his own despair. With reconstitution, the character of the cycle is changed.

In some ways, Rollins + KOS play against the inherent 'meanings' of the texts they employ. Yet this is not even appropriation, when it brings a text back to life. For example, the *X-Men* series takes pages from the *Marvel* comic books, mounting them, unencumbered by further intervention. It belongs to the Kids. In a sense, it always belonged to the Kids. Now they have the power to change its status:

The *X-Men #17* isn't a painting; it isn't a drawing or a print; it really isn't even a ready-made, because it is something that was found, but also something that was already art. Our *X-Men* is an artwork that has changed its social and economic class.[1]

This must be seen as a major tangential leap beyond post-Duchampian appropriationist tactics. The 'appropriation' of the *X-Men* has nothing comparable in the contemporary scene. There are several reasons for this, although the strategy is inevitably difficult to define. Firstly, in our comic culture, the Kids have already claimed the *X-Men* as their own, long before integrating them into their art. The *Marvel* comics are the art of the teenager – all socio-political commentary is contained between their covers. (Rollins + KOS are particularly drawn to the editions published during the Vietnam war, which stand very much as a reflection of the times.) In a way, it is this culture which taught the Kids to read and even to draw: the highest culture on the block. Arriving at the *X-Men* was the result of a pure evolutionary logic. They are texts close to their hearts. Perhaps this series is the sign of the Kids taking control. It is certainly a commentary on power, and power systems. Another reason for this being non-appropriationist must be found in the situation established at the Art + Knowledge workshop, which is entirely painterly, and explicatory. The teasing out of the text is not necessary here, simply its presentation. There is already a deep subjectivity here, in addition to a virtual commentary from Rollins and the Kids. Given the extensive nature of the KOS commentaries, the non-intervention rings loud and clear. Tim Rollins + KOS are quite present in their absence.

Tim Rollins + KOS transcend barriers between class and race, high culture and street culture. This is problematic for some. Yes, there is colonialism of a kind, and indeed there is exploitation. But it must be made quite clear that this operates only on an absolutely reciprocal level. Everyone in the Art + Knowledge workshop has a voice. Some voices are stronger than others, and the balance is always shifting. The important thing is to learn to speak. Rollins has guaranteed this within the fabric of the institution, just as the constitution of the South Bronx Academy of Fine Arts will be based on dialogical activity. Without Rollins as a guiding light, there is no doubt that the journey from the Bronx to Soho would have been a very long one.

There is a kind of cultural interplay at work here which, even within its self-contained little world, could redefine the art world's current concerns with 'worldism', as exemplified by Jean-Hubert Martin's *Les Magiciens de la Terre* show. Somewhere between raw perception and the adoption of refined cultural codes, Rollins and the Kids defy each other, and the machinery which disseminates their work. This work seems only to invest in itself, enriching and regenerating at source. And the lesson learnt does not only move in one direction. It is not just the Kids of Survival who have been led out, but also Tim Rollins, and finally, the work they create together, which stands as its own exegesis. When the book has been read – however it has been read – it remains perpetually open.

Notes

Tim Rollins, in 'Dialogue 5, April 19, 1989, 5pm, The Art & Knowledge Workshop Studio, 965 Longwood Avenue, South Bronx', *Parkett* (collaboration Tim Rollins & KOS), No 20, 1989, p59.

---------- * ----------

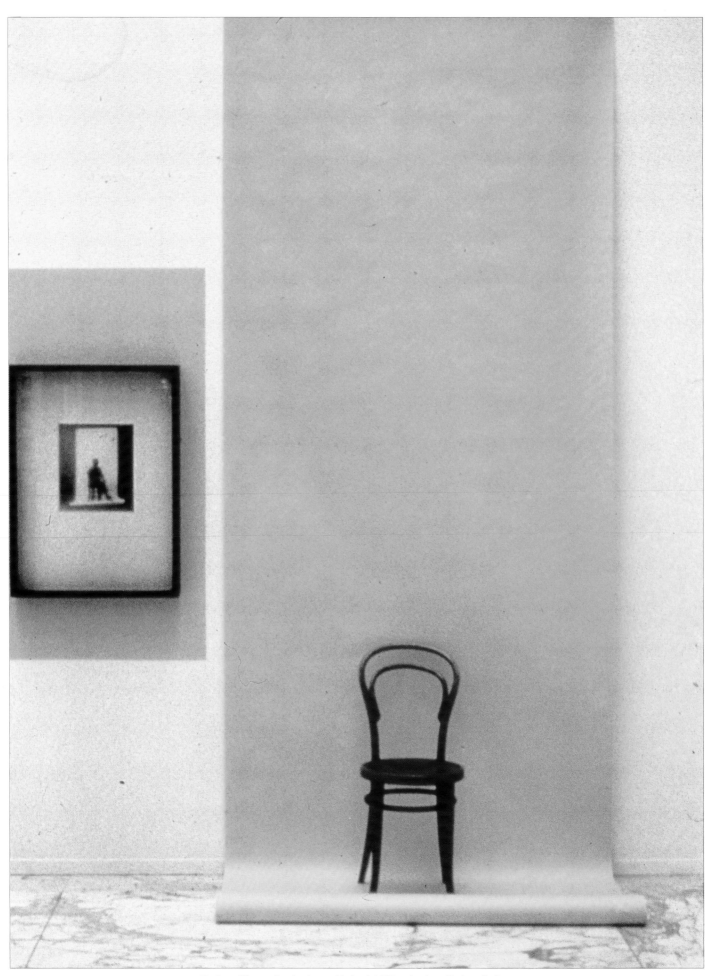

Barbara Bloom, *Confession to Godard*, 1987, mixed media installation

LISA PHILLIPS
IMAGE WORLD: ART AND MEDIA CULTURE

William Beckley, *Deirdre's Lip*, 1979, cibachrome print, 249x406.4cm

'Everything is destined to reappear as simulation. Landscapes as photography, women as the sexual scenario, thoughts as writing, terrorism as fashion and the media, events as television. Things seem only to exist by virtue of this strange destiny. You wonder whether the world itself isn't just here to serve as advertising copy in some other world.' **Jean Baudrillard, America, 1988**

Mass reproduction of the image and its dissemination through the media has changed the nature of contemporary life. In a century that has seen the intrusion of saturation advertising, glossy magazines, movie spectaculars, and TV, our collective sense of reality owes as much to the media as it does to the direct observation of events and natural phenomena. The media has also changed the nature of modern art. As image makers, artists have had to confront the fact that this new visual mass communication system has in some way surpassed art's power to communicate. Over the past 30 years, they have come to terms with the mass media's increasing authority and dominance through a variety of responses – from celebration to critique, analysis to activism, commentary to intervention. The ascendancy of this new visual order has raised a host of critical issues that many artists have felt obliged to confront: Who controls the manufacture of images? Who is being addressed? What are the media's strategies of seduction? Has the media collapsed time and history into a succession of instants? What are the effects of image overload, fragmentation, repetition, standardisation, dislocation? Is the photograph still a carrier of factuality? Where is the site of the real? Is understanding 'reality' a function of representation? All of these questions have directed attention away from aesthetics to the nature of representation itself as the principal problem of our age. Since much of experience is mediated by images, the

issue of how meaning is constructed through them has become central. Artists have also had to recognise that as our relationship to the visual world has changed so has the role we assign to art. This awareness has precipitated nothing less than a complete transformation of the function of art and the conventional guideposts used to define it.

In the 1970s, a new generation was coming of age. Many of these young artists were working in the studios of the California Institute of the Arts, founded in 1961 by Walt Disney.[1] This was a TV, rock-and-roll generation, bred on popular culture, and it took images very seriously. They were media literate, both addicted to and aware of the media's agendas of celebrity making, violence-mongering, and sensationalism.

These artists had been trained to question critically their relationship to social institutions. But, unlike their predecessors and more like Pop artists, many became increasingly cynical about the real possibility of maintaining an oppositional position toward these institutions. What made it difficult was art's increasing public acceptance and absorption into the mainstream of American life. Artists who attempted to make anti-object art that would resist commodification found it necessary to seek some kind of institutional support from museums and alternative spaces in order to have an audience (and often their works were reclaimed by the market). No matter how artists tried, it proved

almost impossible to resist institutional forces. The avant-garde tradition as it had always been known came to an end. The only way for artists to engage it was as an image, a representation.[2]

The conceptual point of convergence for the emerging generation of artists was the recognition that there can be no reality outside representation, since we can only know about things through the forms that articulate them. According to Douglas Crimp, who introduced some of these artists in the landmark *Pictures* exhibition at Artists Space in 1977: 'To an ever greater extent our experience is governed by pictures, pictures in newspapers and magazines, on television and in the cinema. Next to these pictures firsthand experience begins to retreat, to seem more and more trivial. While it once seemed that pictures had the function of interpreting reality, it now seems that they have usurped it. It therefore becomes imperative to understand the picture itself, not in order to uncover a lost reality but to determine how a picture becomes a signifying structure of its own accord.'[3] Pictures, once signs of the real, had been transformed into real objects by TV, advertising, photography and the cinema.[4]

The premise that representation constructs reality has direct implications for theories of subjectivity. It means that gender roles and identity can be seen as the 'effects' of representation.[5] This became a natural line of inquiry, particularly for artists involved with feminist issues. In a group of early collages, Sherrie Levine extracted images of female models from fashion spreads and advertisements and used them as the 'background' material for silhouette portraits of George Washington and Abraham Lincoln. These mass-media depictions of women are literally inscribed and contained within the broader symbolic realm of mythological heroes and great male leaders. In her *Untitled Film Stills* (1977-80), Cindy Sherman takes active control of her own image as she directs herself acting out a series of canned film stereotypes for the camera. She inverts the logic of commodification by exposing self-expression as a limitless replication of existing models (in this case, models defined by masculine desire). In another serial work from the late 1970s, Sarah Charlesworth photocopied the front pages of the *International Herald Tribune* for one month and then blocked out the texts, so that only the masthead, layout, and photo reproductions remained. The sequence of images as well as their sizes and relationship to each other on the page create a new story. The altered pages at first seem to reveal nonsensical, Surrealistic conjunctions of images. But seen as an aggregate they show how the news is presented, who and what is deemed important, and the astonishing paucity of female representation. Deprived of its textual content, the autonomous system of the newspaper page becomes apparent.

Not only do found materials and their re-framing show how social reality and representation 'subject' us, but the process again raises the issues of uniqueness, authorship, and originality, which had always been the defining characteristics of art and greatness. Like the myth of individual creativity, the original and the unique were now seen to be effects of a social fiction of mastery, control, and empowerment. This fiction is made patently manifest in the rephotography of Richard Prince and Sherrie Levine, for instance, where found reproductions were re-presented with little alteration. Only the image's context was changed – but that was enough to make its social codes and their peculiar unreality apparent.

By the end of the 1970s, it was increasingly clear that the deconstructive method had become dry and pedantic. American artists' direct experience of the media's special effects, their awareness of how the media affects our lives, set them off on a fantastic voyage through the media system – its unreality, artifice, immateriality, and replication. Art entered the spectacu-

lar realm, further exploiting the very strategies that made the media so powerful. The works grew dramatically in scale, the surfaces became glossier and more colouful, the imagery more grandiose, and the compositions more graphically arresting. Aesthetics re-entered the art discourse, but with the revised notion of beauty – alienated and weird – offered by the media's spellbinding seductions. The younger generation, at home with this familiar language, nevertheless approached it with a mixture of love and hatred, respect and fear, dependence and resentment.

Pictures of ambivalent and alienated desires emerged. Robert Longo's *Men in the Cities* series (1979-82) is a good example. In these monumental, larger-than-life drawings, conceived by Longo but executed by a commercial illustrator, men and women strike poses that alternately allude to pleasure or pain. The aesthetic was similarly ambiguous in its relation to the media. Was it distanced and critical in its alienated imagery or was it complicit – simply mimicking the media's techniques?

What made the situation confusing was that some artists seemed to combine the crowd-pleasing strategies of entertainment with the spirit of critical investigation.[6] The new politicised style quickly attracted media attention and was offered as an innovative and stimulating commodity. Artists were enlisted as members of the 'research and development' team of commercial culture.[7] Not only was the 'look' of art adopted by commerce, but in the 80s the concept of the avant-garde itself was used as a marketing strategy, most often by concentrating on the artist as personality. Companies such as Cutty Sark, Rose's Lime Juice, Absolut Vodka, Amaretto, and The Gap have featured endorsements by artists ranging from Philip Glass to Ed Ruscha. Over the past few years, the art and entertainment press have repeatedly featured artists, critics, and curators in fashion and life-style spreads as the latest chic commodity. Some artists, however, were quick to discover a newfound power in this development and began to reclaim public spaces usually occupied by the media for their own political messages. Bus shelters (Dennis Adams), electronic signage (Jenny Holzer), flyposters (Barbara Kruger, the Guerrilla Girls), and advertising placards (Gran Fury) are just some of the sites that artists have invaded, interrupting the expected channels of information with compelling visuals and independent voices.

The fame and success artists have acquired in the last decade have presented a dilemma. After analysing and commenting on signs borrowed from the media, they now must encounter their own media image and consider the role they play in the construction of consent. Suddenly their position is unclear: are artists using media strategies in order to expose them or to expose themselves? Even when theoretical justification is vigorously offered, it is often quickly overshadowed by personal publicity and celebrity attention.

Jeff Koons is the hyperrealisation of the contradictions of our age. After selecting sentimental chatchkes, images, and collectibles from pop culture, Koons has them sumptuously executed by expert craftsmen in stainless steel, porcelain, or polychromed wood and enlarged to near human scale. These images of American juvenilia – from TV, film stills, advertisements, and rock music – are themselves the sculptural embodiment of cinematic spectacle. Added to the effect of the works is Koons' carefully conceived PR campaign for his public persona; he has taken control of his own image in the media, packaging himself through a series of elaborately staged, airbrushed 'advertisements' that feature the artist in a variety of situations. These situations – artist with buxom babes, artist at the head of the class, artist as animal trainer – successfully mock the ultraperfect world of advertising, where images of sex and power are used to dominate and control.

But no matter how sharply focused, such messages are far

from clear. One is left with a sense of unreality and incredulity; aware of how images are deployed by the media, we are still held captive by their force and entranced by their narcotic magic. Even if at times it seems that the artist's involvement with media images has become an institution – a new academy of sorts which, by definition, has played itself out – at other times it seems that this art is just at the beginning of an epic scenario. The seductions and manipulations of the media remain so persuasive and powerful that they must be addressed. And artists will continue to respond in unexpected ways.

Notes

1 Among the graduates were David Salle, Matt Mullican, Troy Brauntuch, Sherrie Levine, Allan McCollum, Jack Goldstein, Barbara Bloom, and Larry Johnson. John Baldessari, an original faculty member, taught for 18 years and was a guiding force at Cal Arts, along with Conceptualists Douglas Huebler and Michael Asher.
2 See Hal Foster, 'Between Modernism and the Media', in *Recodings: Art, Spectacle, Cultural Politics*, 1985, Bay Press, Port Townsend, Washington, p35.
3 Douglas Crimp, *Pictures*, exhibition catalogue, 1977, Artists Space, New York, p3.
4 This commingling of art and commerce spawned a new type of exhibition in the late 70s and early 80s – exhibitions that incorporated materials from the mass media (food packaging, anonymous photographs, commercial advertisements). *It's a Gender Show*, 1981, by the artists' collaborative Group Material, Barbara Kruger's *Pictures and Promises: A Display of Advertisings, Slogans and Interventions*, 1981, at the Kitchen, and exhibitions organised individually by Marvin Heiferman and Carol Squiers at PS 1 testified to the global penetration of the mass media and naturally drew critical fire from purists. See Carol Squiers, 'The Monopoly of Appearances', *Flash Art*, No 132, February-March 1987, pp98-100.
5 For further discussion, see Kate Linker, 'When a Rose Only Appears to Be a Rose: Feminism and Representation', *Implosion*, pp189-98.
6 See David Robbins, 'Art After Entertainment', *Art Issues*, No 2, February, 1989, pp8-13; No 3, April, 1989, pp17-20.
7 See Richard Bolton, 'Enlightened Self-Interest', *Afterimage*, 16, February, 1989, pp12-18.

Larry Johnson, *Untitled, (Hard to Believe)*, 1987, ektachrome print, 101.6x101.6cm

James Lee Byars, *The Golden Tower with Changing Tops*, 1989

ANTJE VON GRAEVENITZ
THE ART OF ALCHEMY

Guiseppe Penone, *Contour Lines* (detail), 1989, iron, glass and sand

In the 70s and 80s, artists have been especially occupied with two lines of thought. On the one hand they have hoped, through art, to achieve 'unity', meaning a conception of the clear and the pure, whether in thought or in life itself. Different art movements, especially Conceptual art, represented this idea. Conceptual art demands absolute lucidity of thought, absolute statements about man in

relation to nature and the cosmos, as well as clarity of the selected means – preferably texts and photographs, because one cannot conceal anything with these. Art concerning alchemy is also involved with the idea of unity and purification.

` On the other hand, artists have been occupied with the opposing view that maybe 'unity' can never be achieved and that art enabling us to understand the invisible 'spirit' in the world does not exist any more. Relativity triumphs, as in for example the media which, in its abundance of images, disallows any evaluation; or in physics which, with its theory of quarks and the black hole, derives from the idea that the world is reversible. This is shown by the lack of faith in the wholesomeness of psycho-analysis, assumed by Jacques Lacan in contrast to Freud.

A text by the German artist Jürgen Partenheimer appears symptomatic of these attitudes. In a hand-made book with linocuts, he printed the following: 'In his [Flaubert's] St Anthony, he re-interpreted the temptations as a vision, as a dream of limitless possibilities. The poor fool, the tormented anchorite, is freed from sin. The state of torment becomes a state of fulfilment. Values reverse themselves when we set them in motion: St George, for example, renounces his life and spares the life of the dragon [in us]. End of purification rites. The individual occurrence [the quantum leap] is no longer determined by its previous history. Contemporary scientific insights into the nature of

matter, space, time and gravity have opened up new perspectives for aesthetics. At the vanishing point of our ordered system we no longer perceive the transcending unity, clarity and simplicity of things, but rather the unpredictable contradictory way in which elementary simplicity is annulled [quarks].'

In addition to such analyses, one hears artists claim that there is no longer any unity between culture and society – an opinion that art historian Hans Sedlmayr had already stated in 1948, in his polemical book *Verlust der Mitte* (Loss of the middle). Recently the French philosopher Jean Baudrillard adopted and further expanded this line of thinking, the consequence of which he described as fatal. But this mentality is not in the mainstream of recent art. Artists involved with alchemy, if they ever refer to a lost world, believe in the power of creativity. The proposal of the presence of alchemy in recent art poses the question of whether art itself can be alchemy. Are the purposes and methods of art in accordance with those of alchemy or can one only speak about the adoption or incorporation of alchemic motifs and motivations in art? Why should artists strive for a marriage with alchemy or an incorporation of its motifs and motivations at all? Answers are not easy to find because alchemy, in a sense, is still a secret science. The concept is not exact enough to define; there is not, and probably never was, a common agreement about it, although one could say that alchemists equate processes occur-

James Lee Byars, *The Reading Society of James Lee Byars*, 1987

ring in nature with spiritual processes.

It is specifically this synchronisation of spirit and nature which distinguishes them from science. Moreover, alchemists want to instigate natural and spiritual processes, to influence them, and to be influenced by them, as wisdom and purification – their highest aims – are not learnable. The word 'alchemy' is of Arabic origin, derived from the first alchemist Chymes, later called Zosimus. In the 12th century, the term 'Al Khemia' entered Western Culture, signifying the secret black magic for which alchemists needed books and laboratories. As their doctrine remained accessible only to insiders, alchemy was often condemned as an hermetic science and witchcraft. This condemnation strongly increased at the beginning of the Enlightenment, when chemistry as the science of matter was separated from alchemy – for alchemy had much higher pretensions than chemistry. Because of its connection with art, it is necessary, in this context, to shed more light on these pretensions.

Alchemy is the doctrine that aims at producing the philosophers' stone – gold. Different metals are used to attain this. Fire is used to divide these 'base' metals into their separate components; these are then purified, mixed and ultimately fixed in the final stage as gold. This happens through seven processes: carbonisation, decay, dissolution, distillation, sublimation, combination and fixation. Each process is related to a certain constellation which exerts its influence on nature and man. During these processes the materials change in colour. There are three main colours: black (the colour of decay and carbonisation, the basis for frugality), white (purification), and red (the colour of cold and of blood, consequently of life). The alchemists' recipe consists of a language of signs, colours and materials with symbolic meanings which, when used in the right way, can lead to the 'Great Work'; the purification of the spirit by alchemical gold, also called 'elixir', the philosophers' stone.

The extent to which the alchemist departs from the aims of the scientist is clear. The alchemist always tries, by combining two elements, to produce a third, which in some sense should represent something new. It should therefore have a status totally different from that of the first two. Through the alchemical process, a transformation must take place of two known qualities into a new, preferably absolute quality, that of purity, which is not liable to decay. These are the qualities of gold, which the alchemist considers spiritual; because his own body belongs to the material world, it too must be able to acquire this essential quality of gold. Alchemists share joint goals:

– To gain insights about micro- and macrocosm.

– To demonstrate these by means of thoughts and images or exemplary processes.

– To recognise oneself and be purified in the 'Great Work' – to search for parallels between matter and spirit.

– To harmonise the struggle between the sexes (for example in an androgyne concept) – to recreate the world in an artistic, but not refined, shape.

Since the 19th century, classical alchemy, with its chemical experiments and old metallurgic recipes, was exchanged for artistic and philosophical methods. Letters, syllables, words, dream-visions, images, or the most diverse metaphors and symbols took the place of chemical materials. These materials, spiritual from the very start, through transformational techniques, combination and analogy, effect something new which could give a notion of the universe and help to achieve insight and wisdom. Once it was discovered that classical alchemy could be secularised, it became a suitable medium for all artists and thinkers who considered the exact sciences too limited a refuge. This applies more or less to all art, but alchemy by itself is not yet art and, in my opinion, art is only related to alchemy when the artists consciously apply these aspects in their works.

'I am interested in transformations', I was told in 1982 by the artist Joseph Beuys. 'Transformation is a basic concept. I am searching for the limits towards the religious and spiritual. A desperate attempt to preserve old knowledge in a spiritual way. As long as man fails to realise that money, in the sense of capital, and strictly analytic sciences suppresses his creative power, he is unable to develop . . . The quality of life', he continued, 'lies in asceticism, not in acquiring, since the latter leads to destruction of the consciousness of the future, of beauty, of art. The principle of possessiveness must disappear. Asceticism is very valuable. That is where the gold is – in relinquishing lies gold in a spiritual sense: that is where man's holiness lies.' He found an impressive image for this idea. In 1965, at the Galerie Schmela in Düsseldorf, he showed in a sort of *tableau vivant*, *'How to explain to a dead hare what art is'* ('Wie man dem toten Hasen die Bilder erklärt'). The explanation was not given rationally. His raised finger rather suggests the non-rational statement of saints on painted icons, which refer to 'Erleuchtung' (enlightenment), symbolised by the gold and honey on his head. Honey, in contrast to gold, stands for productive energy.

'Gold as capital', Beuys told me in the same interview regarding his connection to alchemy, 'that is inconceivable. What, then, is gold?' he asked himself and answered: 'To the alchemist it is a metal, the sun. In the alchemist doctrine of symbols, gold, like the sun, is the middle, in the heart, while desire comes from below and the head is above. Above are the higher forms of consciousness: intuition, inspiration and imagination. The heart mediates and the alchemistic gold is aptly placed there.' Beuys considered art not as the visual arts in the classical sense, but as a much wider conception; according to him art mediates between the consciousness of the inorganic world. During his performance at Lucio Amelio in Naples in 1972, he lay on the ground for four hours, rubbing a block of copper with oiled fingers. Next to him was a dry plant, whose Latin name, *vitus agnus castus*, was oriented in sulphor-yellow on a colbalt strip. This flower in the Middle Ages showed the hero Parsifal the way to the temple. *'Vitus agnus castus'* was also the title of Beuys' performance. It called to mind a statement of the first alchemist Chymes/Zosimus: 'Set to work and build a stone temple.' Could not the whole performance and not only the plant be seen as a symbol for the way to the temple? Yellow and blue, the sun and the moon, the male and the female element, Beuys as man rubbing the copper representing the energy-conducting female element: these are all symbols for the abolition of the struggle of the sexes. Beuys linked his own language to traditional alchemists and to Goethe and Rudolf Steiner. This, too, may be considered an alchemistic activity.

The Immaterial Gold

Just like Beuys' action as a searcher for the temple, the work of Yves Klein functions as an 'Anschauungsbild' (symbolic image) for the purification of the soul. On the 26th of January, 1962, Klein sold immaterial work to Dino Buzzati: 20 grammes of gold-leaf, in exchange for a check. Then as Buzzati watched, Klein scattered the gold into the Seine. On another occasion Klein repeated this activity and burned the check as well. This work has the programmatic title, *Session d'une zone de sensibilité pictorale immaterielle* (Session of a zone of immaterial pictorial sensibility). Like Beuys, Klein wanted to transform the gold into a special status of the soul, which he called the zone of sensibility. As a Rosicrucian, he was very conscious of the Parsifal myth: the legend of an untried young man, who must go through various ordeals before he is purified with the 'blue flower' which, according to the myth, showed Parsifal the way to the temple. Yet Klein probably did not intend all this too literally: 'The real blue is inside', he used to explain. In this way

Anselm Kiefer, *Zweistromland*, (*The High Priestess*), Book 80, 1985-89, original photographs mounted on treated lead, 74.3x54.6x7.1cm

his blue acquired the status of gold.

But not only gold is related to alchemy, other methods of making art among contemporary artists are intentionally related to alchemistic acts as well:

– Old symbols were taken up again by Beuys, Marina Abramovic & Ulay, James Lee Byars and Eric Orr.
– New symbols were added (Guiseppe Penone).
– Alchemistic operations and installations return by way of quotation (Terry Fox, Rebecca Horn).
– Purifying rituals are used (George Maciunas, Fox, Byars, Beuys).
– Instruments are presented which the spectator may use to understand the world in a better way (Dennis Oppenheim, Pieter Laurens Mol).
– Melting processes are set free to get new results for paintings (Sigmar Polke, Eric Orr).

The marriage of art and alchemy is possible in many ways. Because of the importance of the 'seven' for the trial and purification of the soul, I want to introduce the 'seven stages' as a possibility of bringing order to the phenomenon of art involving alchemy.

Seven stages

The first stage is that of emblems of the ego, such as the tree of life, the house, the tower and the column. The second consists of melting processes, the third of wishing machines – celibate machines; the forth stage is totally consecrated to levitation and the sixth to the formula: *unus ego et . . .* 'I am one inside me.' The alchemistic gold will complete the seventh stage. However none of the seven stages intend to reflect a hierarchy of subjects. Every work in itself finds the way to the highest alchemistic aim.

Emblems of the Ego

The first stage begins with the labyrinth, an old symbol to purify the ego. Without Ariadne's thread, representing memory, Theseus would not find his way out. In the beginning of the 70s, a lot of American artists such as Alice Aycock, Richard Fleischner, Will Insley and Robert Morris constructed mazes.

The tree of life is described by C G Jung as perhaps the most important ego. He explained how the alchemic tree in the Garden of Eden represents the immortality and knowledge of the highest universal power. The tree of life is also considered the inversion of a kind of womb. To the classical alchemist his oven or distiller

Yves Klein, *L to R: Requiem Blue (Re 20)*, 1960, 200x164.8cm; *Re 40, Bleu*, 1960, 200x150.1cm, both sponge and pigment on board

signified this earth, because he hoped that it could bring forth *athenor*, the philosopher stone. This motive returns in modern art: Giuseppe Penone drove an iron with Fibonacci-numbers into the trunk of a tree, hoping that in this, abstract and natural knowledge could grow together.

The tower is an old purification symbol which the alchemists adopted as *topos* for their seven stages of trials. Purification took place on the top floor. In 1984 the Danish artist Per Kirkeby, at the exhibition *Von hier aus* in Düsseldorf, built a high brick tower inside the exhibition hall, without a staircase or entrance. The imagination could only be stimulated by the suggestion of a tower-form. One of Kirkeby's books of poetry contains a text referring to his work. He describes a tower of a different shape, which one could enter without a staircase directly from the highest floor. 'There was a window, looking out over the sea. There he was alone, his head grew and grew until one eye entirely filled the window. The eye of the tower looked blindly over the horizon.' Kirkeby represents the ego as one who unites with the look-out tower. His eye is blind. Is this because he cannot see beyond the horizon, or because he only looks inside himself? Metaphysical anatomy arises from space in a symboli-

cal architecture occupied by body and spirit.

The column may have the same function as the labyrinth, tower and tree as a symbol for the ego. Byars, at *Documenta 8* in Kassel,1982, showed a golden column in the entrance hall which seemed to carry the spiritual entity of the whole exhibition.

Melting processes
Alchemical melting processes have already been mentioned; they are emphasised in the second stage. Both Anselm Kiefer and Sigmar Polke use melting processes in their paintings. Polke mixes chemical ingredients such as varnish, resin, acid and emulsions, as the old masters would have done, but he is concerned with suggestions of fortuity and surprise as unexpected forms develop. The titles of these paintings have also alchemical parallels: *Negativwert (alkor)*, *Negativwert 1 (Mizar)* etc. One painting is even called programmatically *Conjunction*. Anselm Kiefer used to carry out well-known historical themes from German history, integrating mythical stories from German culture into the imaginary landscape of his paintings. Nowadays he has given up the historical base. Since his visit to Israel, he conjures up Old Testament stories or alchemical histories of

Thérèse Oulton, *Tremolite*, 1989, oil, 167.6x147.3cm

creation, which he connects with the basic ground of his paintings. On the canvas, for example, a thick layer of molten, saturnine lead, resembling a rising cloud of air, melts with the thick paint in earth colours. The title of the painting, *Yggrasil* (1985), refers to the cloud of smoke that arose from the burning bush when God tried to convince the unbelieving Moses of his existence. Both painters focus on melting in analogy to alchemistic principles. On the one hand their paintings take the place of the experimental oven, yet on the other hand they are themselves the product – a transformation of the gold, which can come into existence only by looking and processing.

Celibate machines, wishing machines

Reflecting the spectator's desire for the *athenor*, Marcel Duchamp produced a complicated work, known as the *Large Glass*. It is a so-called celibate machine, which will confront the spectator with the third of the seven stages. Duchamp called it *La mariée mise à nu par ses celibataires, même* (The bride stripped bare by her bachelors, even). Does the bride signify Lady Alchemia or art? Although Duchamp wrote that he was influenced by R Roussel, the author of alchemical stories, he told Arturo Schwarz that if he had used alchemical subjects, it happened without knowing them.

The work was one of the most important sources for the art of Alice Aycock, who likewise in her sculpture constructed non-functioning machines. When I visited her in New York in 1980, she was working on the book *Anti-Oedipe* by Deleuze and Guattari. The concept of wishing machines as a counterpart to the actual machines of production which constitute industry, society and body, seemed to her to be applicable to her 'dream machines', which can 'produce' fears, joy and hallucinations. One work is entitled *How to catch and manufacture ghosts*.

Purification

The classical alchemist, too, was striving to produce, in machines or in his oven, a human soul as the ideal image of an androgynous person. This could happen if he was purified himself and had gone through every trial during the seven stages.

Many events from the beginning of the 60s consist of ritual affiliations of participants, who had to undergo purification rituals. In my opinion, then, it is no coincidence that Alan Kaprow, the pioneer of these happenings, considered purification rituals in modern art as 'the alchemy of the 60s'. The Fluxus movement took part in this, also: the apologist of this movement, George Maciunas, in his famous Fluxus manifesto, proclaiming that the great purification for society and culture is dysentery. As a solution he proposes melting. His word is 'Fuse' with which he puts social unification processes on a level with metallurgical ones. In the manifesto we find 'Purge the world of bourgeois sickness, intellectual, professional and commercialised culture.' Art was given the function of purifying the participant, but the participant had to play his part as well, in order to reach the high purpose. Joseph Beuys, too, always confessed to the ideals of Fluxus, and in his complex performance *Celtic (sinus cosinus)*, he used purgatorial actions: he washed the bare feet of his visitors and, finally, had himself baptised as well. The religious background of these purification rituals is evident. Beuys did not assume the part of Christ, but participated in his work of art, which represented a purification ritual in itself. According to Beuys a work of art must have the power to give people back something which they have lost. In Jannis Kounellis' and Anselm Kiefer's work, purification in the strict sense of the word is no longer relevant. Both artists represent the subject of purification in a symbolic way in their art, which rises like a phoenix from the ashes. Over a small place of sacrifice with ash and soot hangs a palette. Kounellis supports the idea that

energies from history must be understood and preserved to give man back his dignity. The rising of culture from the ashes of the past is his metaphor for a possible recovery.

Although Kiefer's work resembles Kounellis' on the surface, the accent lies elsewhere. He tests in himself and his art the value which history can still have for him. He does not proclaim the same message as Kounellis. He transforms loaded themes from history into his paintings, filters them and thus purifies them. Seen in full light it is carbonised paint which has combined with other paint. His winged palette rises above the black furrows of burnt paint. In this way it seems to be a conclusion of his whole activity as well as alchemic wishful thinking to attain the purgatorial effect of art.

Levitation

Kiefer and Kounellis connect the subject of purgation with the concept of levitation, the fifth stage of my discourse. Levitation represents the consequence of purgation – it means a liberation in the biblical sense as well. Yves Klein, on a Sunday in 1962, jumped from a high wall into the air, which he did not call air, but emptiness, 'le vide'. Although he publicised his jump, just like the visible blue of his monochrome paintings, it was meant as a metaphor for an inner state. Similarly the young Italian artist Marco Bagnoli ascended at sunrise from the heath in Holland in a hot/air balloon. This happened next to a spot where the faces of Bodhisattva seemed to rise from ground. The profiles of the Indian divinity were negative, as if the God had printed his face into the soil. For the spectator, who had been waiting for the spectacle since the dark early morning hours, the energy of the earth, transformed into fire and air, seemed to float away.

Unity

Midgard, to which the sixth stage of this story is devoted, develops by synthesis. Melting, purification and levitation preceed it, until Midgard – the unity, the essence of all this – could develop. It's worth recalling a performance of Marina Abramovic & Ulay which took place in Sidney as well as throughout Europe and America, entitled *Nightsee Crossing*. The two artists sat in front of each other for days at a long table, quiet, introverted, waiting, looking at and into each other and into themselves. First, they tormented their bodies; they actually became cold, stiff and suffered awful pains. Yet they felt themselves approaching a stage in which they could conquer all obstructions and begin to fly as if they had lost their body identity. At the most one can absorb their image and preserve it as an image of stillness and life. It represents a synthesis of the sexes, who nevertheless remain two human bodies, emphasised by two colours, similar to the spiritual unity of the 'chymic marriage' of the two sexes in the old distiller of the alchemist.

Gold

Nuggets of gold lying on the table during a perfomance by Marina Abramovic & Ulay were used as symbols for the *prima materia*, the only spiritual aim of their souls. Gold represents the seventh stage of this discourse.

The question still arises as to whether art can be alchemy. The classical alchemist tried to understand himself by working with material processes. An artist, on the other hand, keeps in touch with the outside world, aiming to communicate with it through his art. This is the main difference between the classical alchemist and the modern artist. The classical alchemist seems to be an individual mythologist, free from ideological dogmas. Contrary to the Modernist artist, the classical alchemist is not searching for a distant goal, but rather a nucleus within himself. With this aim his art may be a real alternative to Post-Modern art with, for example, subjects of 'emptiness' and 'consumption'.

John Baldessari, *Two Stories*, 1987, gelatin silver prints and chromogenic colour prints (C-prints) with acrylic and oil, 243.8x129.5cm

ANDREW BENJAMIN
THE TEMPORALITY OF THE NEW

Fashion is the eternal recurrence of the new. Are there nevertheless motifs of redemption precisely in fashion? **Walter Benjamin.**

The new has a history. History, in addition to providing the new with a continuity, so that what is designated historically as the new forms no more than a harmless self-repetition, also works to construct a specific problem, namely history's 'outside'or history's other. This opens up the possibility of a space beyond the continuity of the new as history and thus as the historical. The new will still be linked to repetition since repetition rather than being overcome can only ever be reworked. Understanding the stakes of reworking will emerge from the attempt to clarify this link. The problem at hand however concerns the consequences of redeploying the new, of using it anew. In sum the redeployment amounts to moving the new from the frame of history in which it functions as a chronological marker – one with the potential to periodise – to the realm of interpretation. Once this move is effected, the immediate consequence is that it will demand a reformulation of time. Historical time will have ceded its centrality to the time of interpretation. This reformulation will concern what will be called the temporality of the new. Time here, if the move from continuity to interpretation is assumed, can no longer be expressed in either historical or chronological terms; *ie* dates or periods. Time, and the new, will form and comprise ineliminable elements within the actuality of interpretation itself.

The new, as part of interpretation, can be seen, already, to figure within a number of predetermined configurations. The new checks continuity; the new as opposed to the old; the new breaks repetition. Within the standard presentation of these configurations, and because the new is only present in them as a marker providing interpretation with the possibility of historical specificity, the components themselves remain unquestioned. Moreover the relation, which links and separates them, fails to be posed as a question. Placing the new within the realm of interpretation will mean that attention must be paid to the claim made by the designation new; *ie* the claim the new makes for itself. The constituent parts within the predetermined configurations will need to be clarified, as will the relation within which the contrast itself comes to be enacted. It is the relation that is, in the end, of greatest significance.

Within the actuality of interpretation, the new will always involve a claim made in relation to tradition. If the claim concerns the affirmed presence of the absolutely new then, though only on the level of intentional logic, this will both isolate and identify that moment or place at which tradition is not renewed.[1] In other words rather than its being a renewing of tradition the absolutely new will intend, in the sense that its logic will work toward, tradition's non-renewal. There is a problem at the centre of this understanding of the new. What is ignored is all implicit mediation that forms part of the designation itself. The new as the absolutely other is already mediated by its being the other. Alterity will therefore involve relation. The inherent presence of mediation brings to the fore that particular paradox of the new. (The new, now, of course, in contrast to the new as the absolutely other.) It is within the terms set by mediation and paradox that the new will come to be situated. It is, for example,

inevitable that tradition is both renewed and not renewed. This inevitability marks both the impossibility of the absolutely new while affirming the possibility of the new. Understanding the paradox does not hinge upon merely understanding the components of the predetermined configurations – old/new, continuity/new, repetition/new – but the relation. How is relation to be thought? Answering this question will involve reiteration.

The claim of the new – a claim that must incorporate the claim to be the new – announces a relation. Within the claim, either of or for the absolutely new, a claim it must be added that has the same status as desire, the relation has to be cancelled. The necessity is binding. The absolutely new must appear as the singular event, one both isolated and isolable. An event whose time – whose now – must be thought in terms of a singular and unmediated present. Again the necessity is binding. Against necessity, in both instances, it must be recognised that the relation that is in fact announced is the one enacted within the denial of relation. The paradox is thereby compounded. Paradox also needs to be retained, thereby introducing a further necessity, for the singularity of the event must be sustained in addition; though not simply as an addition.

The singular event cannot be denied. Its singularity insists within the relation that denies absolute singularity but in which singularity comes to be enacted and maintained. Once again what is essential here is paradox. The singular event comes to be singular only in its not being singular. It is the relation that generates and sustains singularity. Furthermore it is the nature of the relation that is determined by the event. The event's relations, accepting all the complexity that this possessive entails, are themselves the enactment of tradition. Even though the specific form taken by its presence resists automatic generalisation. The result of this is that even though the claim of the new will always involve a particular relation to tradition, the relation cannot be separated from tradition.

The temporality of the singular event, when the event is posed beyond the parameters of paradox, is comprised of a present devoid of mediation. The question of time must be reposed to the extent that it can be argued that present with the event – though not within the event as though the event and the relation were constructed as a type of inside/outside opposition – are the relations that sustain it and which therefore mediate it. How will the temporality of this event be understood? Moreover there is the interrelated question of the nature of the concepts and categories through which this understanding is to take place.

The first thing to note is that neither the Bergsonian concept of *durée,* with its emphasis on pure becoming, nor a present construed as pure intensity can provide the basis for an adequate answer to this question if taken as ends in themselves. Nonetheless they gesture towards such a basis in that neither can account for repetition and thus are to some extent constrained to exclude it. Accepting repetition will allow for a connection to be established between paradox and time. What must be avoided is the either/or in which it would be argued that because the new cannot be reduced to the temporal moment, it thereby follows

95

that the new can never be present, as the new, at the present. While it is inherently problematic trying to incorporate teleology into a projection – be it artistic or interpretative – whose aim is the new, it remains the case that a type of intentionality must be maintained. Retaining a conception of intentionality does not mean that intention is to be ascribed to an authorial subject. On the contrary it will form part of the project and thus pertain to its intentional logic. Displacing the centrality of teleology means removing the specificity that comes to be attached to the telos. Teleology contains 'motifs of redemption' once the teleological is reworked so that it becomes no more than pure project; a throwing forward whose force is internal rather than directional. Yet that internality will itself have or come to acquire direction.

This twofold connection between internality and direction is of fundamental importance. The 'coming to acquire' introduces – or rather reintroduces – repetition since it signals the work's own repetition within interpretation. The repetition of the work – its being given again – cannot be adequately formulated in chronological terms. Chronology would merely account for the site of its repetition. This on its own is not sufficient. What needs to be understood is that further element that sanctions repetition, namely the work itself. This is a complex problem since what is at stake here is the ontology of the work. The work is the site of an original heterogeneity.[2] In other words it sanctions its own repetition – a repetition involving difference rather than identity – within interpretation. Each interpretation will be a singular event, understood as actuality within potentiality. The singular event will however be marked on the one hand by the impossibility of the identity of actuality and potentiality, and on the other by relation. It is only in terms of relation that it is possible for there to be a repetition in which an event takes place for the first time. The reworking of the work is its coming to acquire a determination that is new. The recurrence of the work – recurring as an event – is not the eternal recurrence of the new but a paradoxical repetition in which the reworking of the work means the work's repetition both again and anew. Here the new figures within and as repetition.

Within interpretation the force of the paradox of the again and the anew resides, in part, in the relation that comes to be envisaged with tradition. Tradition is not a description of what has been. Tradition is not perdurable. Despite the fact that it seems to invoke a 'past' – even though it is a past oscillating between the differing though not necessarily conflicting determinations of history and nostalgia, tradition more properly involves dominance and futurity. It is for this reason that tradition can be given the working definition of a determination in advance. The practice of interpretations that work against dominance and the pregiveness of both meaning and propriety will involve a repetition of a work – and thus the generation of an event in which a space is opened and a relation constructed whose determinations cannot be preordained. Once again what is at stake is internality, though an internality with exteriority rather than direction.

Even though the distinction is not absolute it is vital to construct and maintain, if only as strategy, the difference, adumbrated above, between works whose internality has direction and those works which come to acquire it through the process of interpretation and the action of repetition. In the latter case, as was noted, the new involves the paradoxical repetition of the again and the anew. The temporality of this process of reworking and repeating is provided, in part, by the Freudian concept of *Nachträglichkeit*.[3] Repetition becomes the new. The contrast here is with the singular event whose internality is such that the new no longer figures within, in the sense of being sustained by, repetition.

Repetition will figure. In this instance however it pertains to the repetition of tradition. This repetition is neither that of historical continuity nor is it the simple unfolding of dominance. Repetition in this instance involves the concepts and categories handed down by tradition and which determine meaning and understanding.[4] Because of this determination it gives rise to the trap of having to define the new in simply negative terms. The way this can be avoided is by refusing generality. There can be no single way in which the concepts and categories that mark out the possibility of meaning are shown by the presentation of a work, as an event, to be unable to incorporate its 'meaning' within their own terms. The limit, the moment where the question of meaning and propriety remains open, is the new. It is a strategy internal to specific works. The acuity of the problem such works create exists for philosophy. In addition to problems of meaning and understanding there will be the continual need to differentiate the temporality of fashion from that of the new.

Formulating the new in relation to tradition and to the conditions of possibility for meaning and understanding redefines the new in terms of the avant-garde. (It is, of course clear that this redefinition is reciprocal.) In both instances the specificity of the work is central. This is, in part, the reason why the project of the new – the avant-garde project – is not predictive. Prediction necessitates either generality or a form of artistic universality. The challenge that is presented by the new – the new in the sense defined above – because it concerns meaning and understanding, is finding a language, perhaps even a conceptual language, within which, what delimits the newness of the new can find expression. This is the reason why there must be experimentation within modes of writing. The new will demand to be addressed in different ways.

Notes

1 I have aimed at developing the concept of 'intentional logic' in 'Interpreting Reflections: Painting Mirrors', *The Oxford Literary Review*, vol 11, nos 1-2, 1989.

2 An original heterogeneity is a way of providing a description of an ontology of difference that retains the force of the ontological while not involving a commitment to Heidegger's 'ontological difference'. Difference, in the way that I have used the term, is differential. It thereby incorporates value. I have tried to expand upon these concerns in *Translation and the Nature of Philosophy*, Routledge, London, 1989; also in 'Interpreting Reflections: Painting Mirrors' (see above).

3 This key term within Freud's work provides a way of thinking through the concept of repetition. It has been deployed in similiar though different ways by Jean François Lyotard, *Heidegger et 'Les Juifs'*, Paris, Galilée, 1988, and Jean Laplanche, *Nouveaux fonde-* *ments pour la psychanalyse*, PUF, Paris, 1987. The sources in Freud's own writings for this term are few in number. Perhaps the most important text is the neglected *Project for a Scientific Psychology*, even though Freud's formulations are problematic because of the uncritical adoption of a theory of energetics.

4 The role of concepts and categories needs to be explored in relation to Kant's conception of the understanding in *The Critique of Judgement*. The understanding, rather than being simply cognitive, can be made historical in the strict sense that it can function as an analogy for the operation of tradition. The new in this sense is linked to the sublime, not in terms of sublimity itself but rather as marking the limit of the understanding. This in turn would become the limit of tradition. I have analysed some of these issues in 'Spacing and Distancing', *Journal of Philosophy and the Visual Arts*, no 2, Academy Editions, London, 1990.